Hollywood Utopia

HOLLYWOOD UTOPIA

JUSTINE BROWN

NEW STAR BOOKS

VANCOUVER

2002

New Star Books Ltd.
107 - 3477 Commercial Street
Vancouver, BC V5N 4E8
CANADA
www.NewStarBooks.com
info@NewStarBooks.com

Cover by Rayola Graphic Design
Typesetting by New Star Books
Printed & bound in Canada by AGMV Marquis
First printing November 2002

Publication of this work is made possible by grants from the Canada Council, the British Columbia Arts Council, and the Department of Canadian Heritage Book Publishing Industry Development Program.

Le Conseil des Arts | The Canada Council
du Canada | for the Arts

Canada

BRITISH
COLUMBIA
ARTS COUNCIL

NATIONAL LIBRARY OF CANADA CATALOGUING IN PUBLICATION DATA

Brown, Justine, 1965–
 Hollywood utopia

Includes bibliographical references and index.
ISBN 0-921586-90-6

 1. Motion picture industry — California — Los Angeles — History.
2. Motion pictures — Social aspects — United States. I. Title.
PN1993.5.U65B76 2002 384.8'0979494 C2002-910823-3

Contents

Hollywood Utopia

One

Emerald Cities

As they walked on, the green glow became brighter and brighter, and it seemed that at last they were nearing the end of their travels . . .

L. FRANK BAUM,

THE WONDERFUL WIZARD OF OZ

The Emerald City was real.

Before Hollywood, there was the colony at Point Loma, California. The twentieth century beckoned on the horizon as the colony's foundation stone, a heavy green chunk of Irish rock, was laid amid great pageantry on a peninsula curving around San Diego Bay. It was 1897, and almost a thousand people gathered at Point Loma for the ceremony. Soon the community had taken shape in spangled domes and spires and pillars. As the shadows lengthened into night and the burning sun dipped into the sea, painting the western skies in gold, the lights of this little city came up. Its wide transparent domes of many-faceted aquamarine glass were visible from passing ships. Smaller ones shone amethyst, and each dome was topped with a shimmering heart of glass. Under the largest, the central Homestead, the ruler had her vaulted throne room. Beyond the blue-green

domes lay circular white bungalows, nodding palm trees, and opulent gardens of oranges, avocados — all manner of tropical fruits — which perfumed the air. The gardeners were remaking Eden, with plants drawn from the earth's four corners. Beyond the plants lay the eucalyptus trees. There was an ornate Temple of Peace, and elaborate gates — one Roman, one Egyptian — enfolded the settlement. Decorative arts flourished, music was usually audible, and dancers rehearsed outdoors. In the evenings the five hundred costumed citizens of the colony crowded into their marbled Greek amphitheatre for plays; by day they worked raising food, making clothing, or at the printing press. Arts and Crafts-style cottage industry reigned. And everywhere, in orderly rows and smart parade formations, there were children. Lomaland, as it was called, the world headquarters of the Universal Brotherhood and Theosophical Society at Point Loma, was famous for its school. The Theosophists believed that their program could correct the flaws present in man.

The jewelled colony at Point Loma has links to Oz, the imaginary country created by L. Frank Baum, that are worth exploring further. To begin with, Lomaland, like Oz, borders closely on Utopia. Current discussions of Sir Thomas More's *Utopia* (1516) tend to ignore its starring role in the history of fantasy, as well as the mythical cartography that is its essence. The modern understanding of the word "utopia" is remarkably thin, even impoverished. Today utopia has a tinge of the abject about it, conjuring up little more than wilted idealism. No one will admit to being a utopian now. But although the workers' paradise may have been built on utopian foundations, so too are the make-

believe realms of Oz, Wonderland, Never-Neverland, Narnia, Middle Earth, and other dreamscapes. Sir Thomas More's coinage actually plays on two Greek words: *eutopos*, meaning "a good place," and *outopos*, "no place" or "nowhere." The "eutopia" is extroverted, while the "outopia" is introverted. Our age has overemphasized the first sense of the word: the idea of a good or perfect place has received top billing in recent years. Has "no place" therefore exacted its revenge, rendering "a good place" weak and laughable? A balanced reading of utopia must take both senses into account.

An oscillation, the *eutopos / outopos* play between literal and figurative, lies at the heart of utopia. In *Utopia* the earnest element is always undercut by the comical, reminding us that the perfect place is no place at all, a fiction. The character and place-names tell the same story, punning in Greek — the name of the country's explorer, Raphael Hythlodaye, means "conveyer of nonsense"; the name of one of the peoples described, the Polylerites, means "much nonsense"; the capital city of Utopia, Amaurote, translates as "Aircastle" (as in "castles in the air") or "dream town"; a river is called Anider, meaning "no water," and so on. More is always reminding the reader that the perfect commonwealth is imaginary. Utopia becomes a metonymy for all of fiction — i.e., the description of non-existent places.

Utopia takes up certain sober themes from Plato's *Republic*. Some of the arrangements in Utopia seem like More's serious proposals for the good society. For example, the island is governed by a prince democratically elected for life. Family is sacrosanct, but each household consists of several families. Because resources are shared, money is unnecessary. Owning

gold and silver is against the law. *Utopia* gestures at the ideal state in a portrait of a remote island nation, certainly. It is equally a joke travelogue. Hythlodaye claims that he has voyaged with Amerigo Vespucci, the Italian navigator for whom the Americas are named. Playing on the wave of reports from the New World in the early sixteenth century, Vespucci's accounts prominent among them, *Utopia* is bound up in a complex relationship with the age of exploration. We still feel the effects of that relation today, particularly those of us who live on the West Coast of North America. On one level, America has developed out of a literal reading of utopia. Penned soon after Columbus's contact with the New World, More's text parodies travel writing and both embellishes and mocks the idea that a lost Eden or more perfect country might be floating out there, somewhere, in the vast unmapped zones of the world. Two conflicting impulses are at play here: the urge to fantasize and the urge to define precisely the literal truth. The *terra incognita* of speculative maps is rife with wild guesses, empty space, strange distortions, and coiled sea serpents. It is a fantasy that died hard, finally vanishing in the nineteenth century when most of the last, remotest reaches of the world were captured by cartographers, who hunted its sea monsters to extinction.

More's text is thoroughly woven into the history of American settlement. Without Columbus there would be no *Utopia*; ironically, its diffusion into popular consciousness launched countless other ships and settlements, and utopian histories became emblematic of the great and troubled experiment that is America. Because of what Baum biographer Raylyn Moore calls "[European] civilization's westward drift," the utopian fantasy seems to intensify with each westward mile. It is densely woven

LAND OF OZ

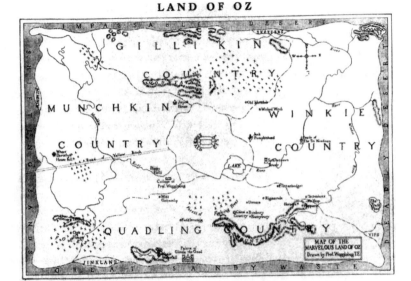

Map of Oz, surrounded by the Deadly Desert. Drawn by "Prof. Wogglebug T.E." (designed by L. Frank Baum). COURTESY OF
MICHAEL PATRICK HEARN

into the dream of the West. So much is clear. But what remains uncharted is the effect of the exhaustion of the geographic unknown on culture. Historian S.E. Mead, considering the effect the prospect of a new continent had on religious thought, observed that space in America has served the function that time served in Europe: the Old World has a fund of history, while the New World has a fund of land. The space beyond the frontier loomed large in the American imagination. What happens at the farthest edge of the continent, when our civilization's westward drift meets the Pacific, when space runs out? With its cinema, its many forms of mysticism, its psychedelia and computer realms, from Southern California to British

Columbia the West Coast has long given rise to fantastical land-
scapes — no-place terrains of limitless possibility. Hollywood,
sects and cults, drug culture, and now cyberspace: has the ter-
mination of new frontiers at the far western edge of the conti-
nent produced a turn to inner space? Has the literal reading of
utopia (a good place) been opened to the figurative (no place)?

～

The author of the Oz books was drawn west in successive
stages. L. Frank Baum was born in Chittenango, New York, in
1856 and grew up near Oneida, one of America's most elabo-
rate utopian colonies. He was a sickly child and had a sickly
child's febrile imagination. As a teenager he was already pub-
lishing, printing magazines on a home press, the first of many
speculative ventures and fever dreams. He soon became
enchanted with the theatrical world and wrote a number of
plays, some of which were produced in Chicago. It was a pas-
sion that never left him. Many of these plays were set in Ire-
land, or had a kind of Irish theme about them — hence,
perhaps, the "Emerald" City. Baum then moved to South
Dakota in hopes of discovering gold. Failing that he opened a
general store, Baum's Bazaar. Unfortunately, like many of his
financial schemes, it was a disaster (apparently he had been too
generous with credit). In Baum's grim gray fictional Kansas we
have a mirror of the hardship he knew in South Dakota. He
seems to have failed in all but one venture: writing for children.
Books began to grow out of bedtime stories Baum told to his
sons. They brought him enough money to continue travelling
west, as far as San Diego.

The family began wintering at the seaside Hotel Del Coron-

ado, on a peninsula just beside Point Loma, in 1898. The hotel was a big Victorian complex of red gingerbread trim, tall cupolas, and turrets. A comfortable mix of old-fashioned elegance and modern accoutrements, "the Del" numbered among the first fully electrified buildings in the country. It had tall palm trees and grounds covering twenty-six acres. Baum made himself entirely at home there, even designing the crown-shaped chandeliers that still hang in the Crown Dining Room today. (Baum was the first of many Hollywood figures to stay at the Del. In the late 1950s director Billy Wilder brought Marilyn Monroe, Jack Lemmon, and Tony Curtis there to shoot the Prohibition period comedy *Some Like It Hot*.) At the turn of the last century, San Diego was a small place, and the fantastical colony growing at Point Loma loomed large in the local imagination. Meanwhile, one of those ongoing Baum family bedtime stories had begun to assume the contours of Oz. As Lomaland developed, the "Royal Historian of Oz" was ensconced in his room at the Hotel Del Coronado, building his Emerald City on paper.

The Wonderful Wizard of Oz appeared in 1900. With a blizzard of fan mail, Baum's readers clamoured for more. One book followed another, and so the narrative fabric of Oz was woven ever larger. The original illustrator, W.W. Denslow, renders Dorothy as brown haired and a bit stout. In the tendrilled and kinetic J.R. Neill illustrations of subsequent books, Dorothy trades in dark braids for a fluffy blond bob, low-belted dresses, and a saucy modern posture. The Wizard's throne is passed to the Scarecrow and finally back to Ozma, the rightful "girl ruler" in her long robes and delicate crown. Dorothy comes and goes. A motley parade of characters passes through

— after the Tin Man, the Scarecrow, and Lion come the swivelling Patchwork Girl, mechanical Tik-Tok, the Sawhorse. Readers followed along eagerly.

Making its initial appearance in *The Wonderful Wizard of Oz* as a green glow on the horizon, the Emerald City is by 1910 "built all of beautiful marbles in which are set a profusion of emeralds, every one exquisitely cut and of very great size. There are other jewels used in the decorations inside the houses and palaces, such as rubies, diamonds, sapphires, amethysts, and turquoises ... All the surrounding country ... was full of pretty and comfortable farmhouses." Just as California must have seemed a fairyland after South Dakota, so the sights and smells of Oz ravish Dorothy after the "dry, gray Prairies" of Kansas. And just as we know it never rains in Southern California, "the weather is always beautiful in Oz." It is a model Eden, "a country of marvelous beauty" with "lovely patches of greensward all about, with stately trees bearing rich and luscious fruits." "Banks of gorgeous flowers," "birds of rare and brilliant plumage," and "a small brook" meet her gaze.

As the earliest Oz scholar, Edward Wagenknecht, recognized with a book called *Utopia Americana*, Oz is a utopia along the lines of William Morris's *News from Nowhere*: agrarian, craftsy, and folksy. Baum revered Morris and the Arts and Crafts movement he founded in England, with its peculiarly nineteenth-century fusion of socialism and nostalgia. Most utopians fix their gaze on the future, but William Morris looked backwards in time to an idealized Middle Ages. He inspired the appreciation of handcrafted, rustic objects — fabric, furniture, ceramics, stained glass, beautifully hand-printed paper, and more — among the elites. Today the Arts and Crafts style is more wide-

spread than ever. But Morris was not only interested in aesthetics. He also devised a plan to revive the medieval guild system. Like other members of the Pre-Raphaelite Brotherhood, Morris saw in medieval social life a kind of connectedness to work that had been lost with industrialism. This folk dignity is everywhere apparent in the civilized parts of Oz, where "everyone seemed happy and contented and prosperous."

Like More's vision before it, Oz is isolated, communal, and idealistic. It is also rather fragile. The threat of invasion shadows many of the stories. The semi-rectangular country is bordered by a Deadly Desert, which evokes the Great American Desert of far-western territories like Kansas, Colorado, Utah, and Nevada — the unexplored regions beyond the frontier. This idea, so suggestive for the American imagination, was one which Baum would have remembered from childhood: portions of the Great American Desert were mapped within his lifetime. He seems to place his fantasy kingdom in the uncharted parts of America. Much of the potency of Oz lay in the elaboration of the fantasy of an undiscovered realm even as such possibilities were being extinguished in America (along with the sovereignty of native tribes). The myth was transmuted and redesignated. It died and was reborn as Oz.

At another level, Oz is a shadow America, preserving the sense of what might have been. It is fitting, therefore, that the threat of discovery always hangs over the region. Ozites are menaced by evil spirits on the one hand and human technology on the other. Human eyes might soon penetrate every corner of the world, for as Ozma observes apprehensively, "the earth people have invented airships." Oz has no army, save one old soldier with green whiskers and flowers in his gun. Ozma, a

pacifist, "will not fight – even to save my kingdom" because she believes it is wrong to kill any living thing. Rather than stand idly by as Zeppelins float over the Emerald City, Ozma renders her domain invisible.

Baum cultivated a close correspondence with his faithful fans. In 1905, now quite well-off, he announced to them his purchase of a tiny island off San Diego called Pedloe, which he designated a miniature Oz. He held a competition and selected an eleven-year-old reader to be crowned Princess. Baum assured the ringleted nymph, who lived in San Francisco, that she would soon begin her reign over the sunny island Oz. Pedloe would be renamed and refurbished, its land quartered into Munchkin, Gillikin, Quadling, and Winkie territories. The sea would stand in for the protective Deadly Desert. The glistening vista of the capital was to be erected at its centre, together with statues of all the famous figures, and a monument to Jack Pumpkinhead would go up at Wizard's Point. The tiny kingdom would open its gates to children everywhere. But the plan evaporated, perhaps because Pedloe Island is a mirage. Raylyn Moore, one of Baum's later biographers, conducted a thorough search of survey maps and found no island fitting the writer's account of the one he had bought.

Oz is vulnerable because it is perfect: gorgeous and civilized (except for some bits of wilderness in the Gillikin and Quadling regions that also evoke the American continent). There is no money, no rich, no poor. We are told that "Each person was given freely by his neighbors whatever he required for his use, which is as much as anyone may reasonably desire." Best of all, there is no death. Baum, who found the Brothers Grimm stories brutal and shocking, set out to tell tales that would, as he

put it, "bear the stamp of our times and depict the progressive fairies of today." He peppers his own texts with friendly tips and instructions. It is Baum's use of the word "progressive," his shiny optimism, and his desire to ignore or excise evil that make him so eminently American — so Californian, in fact. He shared this mindset with the Theosophists at Point Loma. Theosophy, another of the strands in the little web of correspondences linking Oz to Point Loma, was a doctrine of human perfectibility. A kindred spirit and close neighbour, Baum had much in common with Point Lomans. And he and his wife, Maud, were members of the Theosophical Society.

~

To paraphrase Mike Davis, there is nothing particularly new in the New Age. As he writes in *City of Quartz: Excavating the Future in Los Angeles*, people often suppose that the New Age movement sprang fully formed from the 1960s Age of Aquarius, but in fact "it has a complex subcultural genealogy, being related to Bloomsbury and an earlier Pre-Raphaelite bohemia, as well as deriving, more locally, from a concatenation of Arroyo-ite Aryanism (especially the emphasis on racial physical perfection) and Hollywood cult tradition (including a Satanic chromosome or two from the influential Crowleyites)." I would point more specifically to Theosophy. New Age, the fusion of American self-help discourse with varieties of Eastern mysticism, is extremely close to nineteenth-century Theosophy (there have been several versions since the Renaissance). Madame Helena Petrovna Blavatsky's Theosophy ("divine wisdom," from the Greek word *theosophos*, "wise concerning God") grew out of Spiritism, which promised contact with the

souls of the dead, as well as assorted other spectral entities. Occult practice calls not on God or gods but rather on the inhabitants of intermediate zones: the messengers with their wise words for humanity (the croaking tones of "channelling" today). At some point the spirits, with their endless chattering stream of banality, began to pall on Blavatsky. She did not deny the shades' existence, only their relevance. The spirits spoke at cross-purposes. Spiritism held little promise for human improvement. "True spiritism should be a culture of spirits with the living, not a commerce of souls with the dead," she decided. Her synthesis of world religions would favour human beings over the unseen others. Evacuating the underworld for the land of the living, in 1875 she founded the more practically oriented Universal Brotherhood and Theosophical Society, which was built upon three progressive main precepts:

- To form a nucleus of a Universal Brotherhood of Humanity without distinction of race, creed, sex, caste, or colour.
- To promote the study of Aryan and other Eastern literature, religions, and sciences.
- To investigate the hidden mysteries of Nature and the psychical powers latent in man.

In transforming Spiritism into Theosophy, Blavatsky became a utopian. It is possible to see in this development a growing millenarianism as the turn of the century approached, a mood which resurfaced with new intensity in the late twentieth century. Nowadays New Agers like the writer Terence McKenna talk quite casually of "dissolving the monkey body" in a breathtaking evolutionary burst and "refining ourselves as

pure information." The idea is that humanity stands on the brink of a spectacular change in nature. As Blavatsky's follower, the regent of Lomaland, Katherine Tingley, put it in her book *Theosophy: the Way of the Mystic*, "It is impossible to gauge the significance of the present time or to realize what is in store for humanity during the next hundred years ... For this is no ordinary time." She predicted that Theosophists would rise to meet that challenge, envisioning a "release ... [of] human life from its digressions." The language of *progression* and *digression* and elsewhere *retrogression* pointed to some achievable future bliss, to our "divine inheritance and immeasurable possibilities of evolution." One evolutionary goal was world peace, a theme that Tingley returned to again and again. Peace was man's future, and Theosophy would bring about the conditions for this great change in human nature. As one Point Loma publication confidently promised, "In the splendor of a perfect day, brother shall meet brother, soul shall greet soul, and all humanity shall be united, and there shall be PEACE! PEACE! PEACE!"

"Man is divine," wrote Tingley in an echo of her hypnotic Ukrainian teacher. But human nature is split between struggling good and evil angels, the parallel worlds of the essentially divine and the essentially demonic. (It is a struggle, incidentally, which is allegorized in Baum's *Emerald City of Oz* of 1910, which portrays the efforts of the ill-natured Nome King to tunnel up into sunny Oz and conquer it. Chapters alternate between the Nomes underground and the Ozites above as if between parallel realities. Princess Ozma is firm but kind: "I must not blame King Roquat too severely, for he is a Nome, and his nature is not so gentle as my own." Ozma refuses to raise an

army against him, and instead manages to defeat him with love and magic.) These are no alien forces: man himself embodies good and evil. The keys to perfection, however, lie within reach. Godlike perfection is merely *latent*, a potential, and humanity has the strength to raise itself out of degradation without outside agency. Jesus is held up alongside the Buddha as an example of human perfectibility, but the task of "adjusting and redeeming humanity" is deflected from Jesus onto man. Jesus, Buddha, and other so-called World Teachers are models of success, flawless. Tingley claimed that Theosophy could reshape anyone, and introduced plans for treating convicts in Theosophical "hospitals," where they would make art, meditate, pray, and study Theosophy's favourite texts. Unformed schoolchildren and spiritually misshapen prisoners alike would be malleable.

Point Loma itself was intended as a showcase of success. It was, in all its radiance, the demonstration of the power of the Theosophical prescription: humanity could reform itself and "bring about a new order of things." The importance of the site in this scheme cannot be overstated. Katherine Tingley was resolved from the beginning of her Theosophical career to found a colony as far west as possible. California, which boasted more Theosophical lodges than any other state, was bursting with promise.

Mike Davis notes that for many newcomers, Southern California was "the promised land of a millenarian Anglo-Saxon racial odyssey" and "the last outpost of Nordic civilization." It would be unfair to lump the Theosophists in with this group, despite their insistence on "Aryan" teachings. Theosophists did not use this word the way the Nazis did — as a rebuke to the Jews. Blavatsky had used "Aryan" to evoke India, perhaps as a

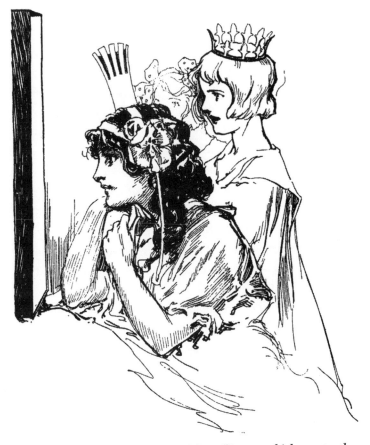

Ozma and Dorothy in front of the Magic Picture, which constantly changes its scenes, showing events happening all over the world.

ILLUSTRATION BY J.R. NEILL, IN *THE SCARECROW OF OZ*, AMEREON HOUSE, 1915

way of linking Indian traditions to European ones, since Theosophy borrowed heavily from Indian religions. Tingley's vision of California's destiny actually entailed a break with Europe. California was to be the site of the emergence of a new "root

race," by which she meant a newly potent civilization that would take over from the incumbent European-Aryan one worldwide. Some of Blavatsky's other prominent disciples had reached similar conclusions. Annie Besant, for example, argued that a freshly evolved form of humanity had arisen in California, with specific skull formations and enhanced powers of intuition. Moreover, Tingley wanted to send archaeologists from Point Loma to excavate Mayan and Aztec cities and prove that America was the oldest civilization of all. America would be at once the oldest and the newest of cultures, combining depth and authority with youthful glamour, force, and possibility. California would rule the world.

Even now the word "California" is redolent of vitality, conjuring up images of sunshine, bronzed musculature, trees heavy with fruit – an endless summer. A century ago it seemed a most auspicious environment for the rebirth of humanity in all its latent godliness. In the ideal Theosophical realm, as in Oz, there would be no hunger, no illness, no aging – or not much. As for death, Theosophists envisioned a hierarchy of reincarnation along Hindu lines. The most enlightened beings, after a powerfully accomplished stint as humans, would assent to death as to a pleasure voyage. (Baum too believed in reincarnation, expressing in a late letter to his son his certainty of being reunited with his wife Maud in a new body). Disciples would find new longevity in the bright light, salty breezes, and greenery of Point Loma, California, breaking from healthful work to loll in the fragrant gardens, reclaiming the legacy that was Adam's. It was a vision of prelapsarian life.

Point Loma, best understood in terms of spectacle, was a display case for Theosophy. Life there took shape around Tin-

gley's notion of theatre as sacrament. Of all the territory shared between Oz and Lomaland — whimsical jewelled architecture, utopianism, Theosophy itself, Edenic landscapes, the female monarch, her pacifist principles, magical health and longevity, children in general and education in particular, William Morris and the Arts and Crafts aesthetic — drama holds a special place. It is highly likely that the theatre-loving Baums attended one or more Point Loman plays when they were staying just across the bay at the Hotel Del Coronado. Tingley, who had at a young age bolted from marriage to become an actress in a stock repertory company, was, like Baum, passionate about drama and fine costumes. As celebrant, director, and performer, Tingley was always the focus of events in Lomaland. "True drama points away from unrealities to the true life of the soul," she wrote. Writer Peter Washington describes Point Loma as "closer to Hollywood than Jerusalem." If anything, the Theosophical colony anticipated the film colony, for Point Loman theatrics were well established when the movies came to Los Angeles about 1909 (and even then the movie productions were comparatively primitive). Perhaps Tingley set the stage for the film industry with her intricate inaugural ceremonies at Point Loma at the cusp of the century, which attracted hundreds of disciples and a considerable chunk of the San Diego citizenry.

The air was electric with anticipation that evening. High above the plunging waves, the vast crowd stood for speeches, songs, and dances performed by the robed acolytes. The orchestra played Mascagni's "Intermezzo" while Katherine Tingley, wearing an embroidered gown of royal purple, sprinkled oil, corn, and wine on the cornerstone. This performance set the tone for the years to follow, when Point Lomans played Shake-

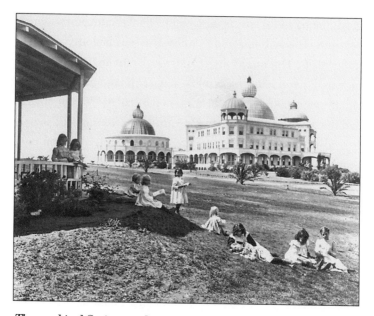

Theosophical Society students reading on the lawn outside the Homestead, Point Loma, circa 1905. PHOTO COURTESY OF THE SAN DIEGO HISTORICAL SOCIETY

speare and Aeschylus for the townsfolk in an arresting display of community effort – the whole of Lomaland participated in these efforts in some way. The cast for *A Midsummer Night's Dream*, an especially popular production, was immense. Children of all ages appeared as fairies, costumed in gauze and ribbons, with flowers from the fragrant gardens wound into their long hair. The play went over so well that a train was hired to take the whole cast (150 people) to Los Angeles for a special performance. Another local favourite was the colonists' version of the pastoral *As You Like It*. From the elaborate Greek amphitheatre (the first such structure built in the state, it seated

2,500) the crowd could gaze out over the mosaic floor and beyond to the sparkling Pacific. These performances became so popular that Point Lomans began to charge admission in order to limit the number of guests – and to raise money for the colony, naturally. Tingley also took over the Fisher Opera House in San Diego, renaming it the Isis Theater, and began entertaining the locals with a combination of ritual and drama.

Drama, dance, and music were sacrosanct at the Rajah Yoga ("kingly union") school, which had 300 students in 1910. This school, which was based on the idea of a perfect balance between physical, mental, and spiritual faculties, is an ancestor of the highly regarded Rudolph Steiner or Waldorf schools of today. (Steiner's Anthroposophy movement is closely related to Theosophy.) The school was the community's central show-piece, with the sparkling transparent domes of Point Loma emblematizing the radiant nature of the students. However, Rajah Yoga has been described in slightly ambivalent terms by some former students. Children born at Point Loma were soon separated from their parents and raised in a communal nurs-ery, where the parents could visit them once a week. From there the children went to live at the school, where they were joined by a great many boarders, some from as far away as Japan and South Africa. Although they studied formally for only two-and-a-half hours a day, devoting the rest of their time to arts and sports, students were able to stun visitors with their displays of knowledge. And there were many visitors. The bril-liantly accomplished children showed the world that human nature could be mastered and raised to a new loftiness.

Surly children would be given a mirror and told to smile into it until their good natures returned. In the name of taming their

"brutish" shadow side, the children's existence was flooded with a penetrating light. They were constantly under scrutiny. Although (or perhaps because) corporal punishment was not permitted, discipline was rigid. They were never alone by day, and the white cottage-dormitories were designed panopticon-style to foreclose privacy: circular, with a teacher at the centre and beds radiating outwards. Every bed was in the watchful guardian's line of vision. Reportedly, older kids were sometimes strapped in at night to stave off masturbation. In a similar vein, parties were rigorously chaperoned. Ballroom dancing and the waltz in particular were forbidden. Girls had to wear ankle-length skirts, even in the 1920s, and were forbidden to bob their hair for the Clara Bow-style sex appeal that adolescents coveted in that era.

The visitors were also struck by the military ambiance of Lomaland. Children and adults alike wore uniforms sewn by the women and marched smartly around saluting their betters. The social hierarchy reflected individual spiritual progress, a progress which was in theory possible for everyone – but it was definitely a hierarchy. Strictly organized, the colony was undeniably productive. The California Avocado Association reported in 1928 that the colony was harvesting 123,158 pounds of various kinds of fruit and 2,552 pounds of honey per year. Horticulturists experimented with new strains in the lavish gardens. All manner of fruits and flowers appeared on the communal tables. There was a dairy farm. Although the community wasn't completely self-sufficient, it did produce about half of its food and most of its clothing. William Morris-style, fabric was handwoven and dyed spectacular hues, and the hand printing press churned out stacks of colourfully illustrated magazines and

books. The Point Loma printshop won an international award in 1914. Other craft items included painted china, leatherwork, and doll furniture. These were sold to the tourists, who came in great numbers.

People worked hard; the intensity of their work was an index of their enlightenment. They were proud of Lomaland and its Purple Mother. There were a few shadows, however. The fact that Tingley permitted herself a wardrobe of fancy and fashionable gowns while everyone else roamed around in uniforms or togas was a particular source of bitterness for some Point Lomans. Inevitably, charisma cuts both ways. The radiant personality that gave light and life to Point Loma also lorded over it to some degree. The fact that this *de facto* monarchy mirrored the spiritual hierarchy inscribed by Theosophy didn't prevent some inhabitants from resenting her impulsive decrees and sudden changes of heart. Over the years she made rather a lot of enemies both within and without the gates of Lomaland. Some San Diegans were piqued by what they saw as the spiritual arrogance of the community. Unsurprisingly, Tingley rapidly fell out with local Catholic and Protestant clergy, whose "old-fashioned theology" she poured scorn on. Together they drew up a petition against Theosophy. Her rivalry with Theosophist leader Annie Besant – Theosophy had split in two after Madame Blavatsky's death – was chronicled gleefully in a *New York Times* article entitled "Battle of the Fair Theosophists." The "cult"-hating editor of the *Los Angeles Times* bombarded the enclosure with bad press, designating it "the spookery" in reference to Spiritism, and alleging child abuse and perversion. The reports suggested that the students were starved and overworked, and that the ceremonies were somehow sexually

depraved. Tingley shot back with a libel suit and won. She was awarded $7,000.

Her followers put aside any feelings of hostility in 1929, however, when their Purple Mother perished in a car accident while travelling in Europe. It was an ill-starred year for Point Loma. The group appointed a new leader, a scholar of Sanskrit named Gottfried de Purucker who had lived among them for many years. He had an ambitious program for community development, but it was not the historical moment for ambitious programs. After the stock market crash demolished many of its wealthy benefactors, the community had to curtail operations. The extravagant irrigation system was one of the first things to feel the budget cuts, and bit by bit the rich plantations dried up. As the Depression intensified through the 1930s, parcels of land were gradually sold off. The eucalyptus groves and wide fields diminished and buildings fell into disuse. Soon only the domes remained, and the Theosophists moved to more modest surroundings. Few utopian settlements survived the Depression.

Point Loma's fortunes did not recover with World War II as America's did. Still, it followed a strange Ozite chronology. In 1939 the famous movie version starring Judy Garland was released, and so even as the lights of one Emerald City illuminated screens across the country, the lights of another were being snuffed out. In 1942 Point Loma was officially disbanded, but for some years the blue-green domes remained as a beacon, sparkling blue-green by day, orange with the sunset, and finally fading to black.

Baum had long since joined the whispering spirits when his greatest triumph came. But it is fair to say he had a hand in making the MGM musical. Some happy instinct drew him in

1909 to settle in Hollywood, several years before the name became synonymous with the movies. At that time it was little more than a sunny retirement community. The film industry was in its infancy, and Baum saw it grow up to the brink of the dazzling Twenties. Ever the dreamer, he founded his own tiny studio down the street from Ozcot, the family home, and began shooting the wispy precursors of the movie we all know − a silent *Wizard*, a mute *Scarecrow of Oz*, a ghostly flickering *Patchwork Girl*. He wanted to offer cheap tickets to Oz. With their candy-coloured plates the books were expensive, but with a five-cent movie ticket any child could travel to the Emerald City. The fame of Oz spread far and wide during the twentieth century, generating fan clubs and industries in its wake. Many interpretations have been offered − political, social, spiritual − but none has reduced Oz to a single cartography. We don't know for certain whether there are traces of Lomaland in Baum's creation. It is equally a pleasure to imagine these mirror worlds springing up through sheer coincidence, and that Baum and Tingley remained serenely unaware of one another. It may be a remarkable pattern in California dreaming at work here, and no conscious modelling at all. For even the best-cut keys to the Emerald City will ultimately leave us fumbling at its gates.

Two

White Magic

A map of the world that does not include Utopia is not worth even glancing at ...

OSCAR WILDE, *THE SOUL OF MAN UNDER SOCIALISM*

The Battle of the Fair Theosophists raged on well into the new century. Annie Besant's followers, the "Adyar" branch Theosophists, founded the rival settlement of Krotona in a sparsely populated village called Hollywood. The Krotonans were delighted with their fifteen rolling acres, uniquely placed in hills which lay between the desert and the blue Pacific. Narrow trails traversed the landscape. The place was heavenly in those days, a banquet of scent and sound and sight. By day, white light flooded the scene, for the sun shone 350 days a year; at sunset everything was glutted with gold. The salt sea tang mixed with that of sagebrush blowing in from the desert. Nightfall brought the howls of coyotes and the whispering steps of tiny deer and of wild rabbits. The townspeople — sober churchgoing farmers from the Midwest, mostly — cultivated lemon and orange groves, and the velvety night air was thick with citrus. Pepper trees lined the unpaved streets, raining down their red

fruit. Papery bright poppies grew all around. All in all it seemed a perfect place for a religious colony: perfectly furnished with natural beauty, isolated, and well protected by the strict and abstemious locals, who brandished flaming swords at the gates of their Eden. The farmers meant to keep their town pure. They declared prohibition that year (well in advance of the U.S. Congress) and brought in a host of bylaws designed to exclude the noise and dirt of heavy industry. Turning down proposals for a gasworks and a slaughterhouse, they promoted cheap and sunny Hollywood as a retirement haven, beckoning in prosperous folk like L. Frank Baum. The Krotonans believed they had found a secure home.

The only unforeseen element was the slow but steady trickle of film people into the area. Prohibition had backfired in Hollywood town: when the local saloon was forced to shut down, its owner, a Frenchman by the name of Blondeau, leased it to a New Jersey film company called Centaur. This modest roadhouse became Nestor Studio, the first film studio in Hollywood. It was 1911, and the wildfire spread of "flickers" across America had really only just begun. The industry was young and fragile. As a result, the lawmakers of Hollywood scarcely had language to describe the activities of these people — "movies," as the film folk themselves were derisively labeled. As Krotona took shape in the hills, so too did the foundations of the cinematic city that would give the name of Hollywood its thick glossy patina. And like Krotona, this place had a utopian dimension, one whose contours are now scarcely visible through the dense fog of glamour that hangs about the place. Figures like Kenneth Anger, the author of *Hollywood Babylon*, have underscored the dark and uncanny side of the early years of "Tinseltown." We

know all about Hollywood Babylon, but very little of Hollywood Utopia. This utopian dimension consists in several things. Firstly, the very emergence of a pioneering *film colony*. This was an experiment based upon an innovation, namely film itself. It consists in the *outopos* of cinema, with its infinitude of fictional universes nowhere to be found. And Hollywood Utopia consists in the now-forgotten idealism of silent film: the dream of a universal language. In the midst of World War I, artists like D.W. Griffith and Lillian Gish hoped that by transcending geographical and linguistic barriers the screen pantomime of cinema might unite mankind. Mirage-like, Hollywood's utopian aspect soon faded. But we can still sketch its outline.

What brought Griffith and the other moviemakers there? Hollywood in 1911 was nowhere and nothing, a scratch on the map, the merest one-horse town. "Hollywood didn't mean a thing," as Griffith's wife, Linda Arvidson, phrased it. Cinema was in its fretful babyhood. "The flickers" were unformed and lowbrow, as Griffith knew only too well. Griffith, who personifies more than any single figure the history of the American silent screen, treasured high culture. Born in 1875 into frayed gentility, the son of a former Confederate colonel, he grew up in Kentucky steeped in book-learning. When Griffith was seven his father died. He took with him the vestiges of an idealized Southern past and left his family poverty-stricken. Griffith became involved with theatre early on, acting in a number of plays, but wasn't particularly successful. He was poor enough at the turn of the century to contemplate appearing in movies, a strictly proletarian entertainment at the time. He hoped to make a little cash while the fad lasted.

To trace Griffith's movie career is to trace the arc of silent-

film history – from seedy obscurity to brilliance, and thence to oblivion. The flickers flared up around the turn of the century only to die down as the novelty wore off. The excitement over *fin-de-siècle* technology like electricity, the telephone, photography, and moving pictures – what the French termed *magie blanche* (white magic) – evaporated as people began to take it all for granted. What had been thrilling – to see leaves rustle in the wind, a woman pedalling a bicycle, even the more fantastical images of Méliès the magician – soon palled. Movies in America had other things working against them as well. These nickelodeon flicks were lowbrow and they ran in the dark. Darkness provoked and concealed all kinds of vice. The movies ran in shabby storefronts and tattered fair tents, quite unlike the lavish venues for vaudeville and live drama. They didn't make much money. People worried about hygiene. The movie houses were imagined as swampy and fetid, dirty in every sense. Many were closed down by public health officials. Rumour had it that cinema harmed the eyes. There was no merit and no future in the "galloping tintypes."

Motion pictures found new life in Edwin S. Porter's *Great Train Robbery* of 1903. This movie *told a story*, and told it in a new way entirely distinct from live drama. It reignited public interest in the form. Its narrative was composed of the editing tricks and shifts in perspective that we call *cinema*. In 1903 these innovations were arresting and hair-raising enough to send audiences shrieking under their seats when a train seemed on the verge of hurtling off the screen, or when, in the final frame, a gunman shoots a blank straight into the camera. Audiences were transfixed, emotionally engaged, and hungry for more such stories. Another important Porter film was *Life of*

an American Fireman (1903), featuring sophisticated cutting techniques which built tension and engaged the audience's emotion.

Griffith made his film debut as a heroic lumberjack who saves an infant in Porter's *Rescued from an Eagle's Nest* (1907). Griffith, who always considered himself homely, must have been horrified to behold his long face, great beak of a nose, and ice-pale eyes in motion. In any case he soon began writing, turning out scenarios for Porter. In 1908 he joined the Biograph Company of New York as a director. Biograph was one of a number of fledgling companies trying to capitalize on the modest potential of movies. They lured stage actors in with higher wages and regular work. Biograph also promised anonymity — no one received credit — which sheltered the actors' reputations. The theatrical world poured scorn on movie actors: they were little better than streetwalkers. Some theatrical contracts promised instant dismissal to anyone caught acting in the lowly flickers. When the young stage actress Mary Pickford was persuaded by her manager mother to work under Griffith for ten dollars a day, her great concern was to protect her theatrical future. "I used to pray that no-one from the theatre world would see me going up the Biograph steps," she later wrote. Her theatre connections tut-tutted gloomily about this decision.

Movie production was raw and experimental. Most companies shot in New York or New Jersey, on rooftop stages that were rigged up to swivel, following the passage of the sun. Electric light was still too weak to adequately illuminate the set. Action, romance, comedy — everything happened on the roof. But that system faltered in the dark and freezing winter months. Some

companies tried shooting in Florida, but the weather was humid and turbulent. Storms would rush in unexpectedly, whipping the sets into chaos and drenching the players.

Another problem with East Coast filmmaking was posed by Thomas Edison. The white magic wizard had produced the electric lightbulb and the phonograph player; he was a hero of the age. But Edison's genius masked considerable greed and worldly ambition. In his lifetime he took out over 1,000 patents, but not necessarily for things he had actually invented. He understood the patents system well at a time when many others did not. Always alert to new ideas in Europe and America, he was often able to translate someone else's tentative experiments into something concrete, gaining fame and fortune in the process. He strained to take credit for the invention of the moving picture, which was probably pioneered by William Friese-Greene. Several inventors seem to have been tinkering with the idea simultaneously. Edison commercialized it. In 1896 he demonstrated a projector called the Vitascope. The Vitascope was designed by Thomas Armat, but Edison snatched the laurels. He was determined to control the growth of motion pictures in America. He had potentially lucrative patents at stake, including one on a crucial piece of the camera. Edison insisted that his invention was being pirated by the small film companies in New York and New Jersey. So started what is known as the Patents War. In addition to pelting the other companies with lawsuits, Edison hired gangsters to go round and smash their cameras to bits during production. Rooftop shooting was frequently interrupted by the arrival of thugs who busted up the cameras and scared the actors. Often the gangsters torched the studios as well.

Edison helped drive the moviemakers into the West. Boarding the cross-country railway, they fled to the warm fragrant embrace of California. It is one of the great paradoxes of Los Angeles that *place* made American movies what they are. Paradoxical, because in a place which is notoriously rootless and witless and boundless and lacks a civic heart, the entire notion of place is troubled. The fact remains, however, that the particularities of that landscape made the movies as we know them possible. Southern California and the movies rose to power interdependently: the landscape of Southern California made "Hollywood," and "Hollywood" made Southern California. Light brought moviemaking to Los Angeles — the bright white light necessary for shooting in the days before strong electric lights — together with a whole spectrum of geographical features. Light, beaches, ocean, mountains, desert, and cityscape, all in close proximity, these were the things that drew the fledgling industry. The Southern California landscape would eventually stand in for every place on earth. It was a nowhereland that would become a map of the whole world. It was cheap and perfectly situated, far from New York and close to the escape hatch of the Mexican border in case of a flare-up in the Patents War. In addition to light and location, Southern California had labour. While San Francisco was thoroughly unionized, Los Angeles was in those days a non-union city with plenty of cheap Mexican and Asian workers.

Hollywood was a frontier town, rough and unformed. Sunset Boulevard was a cattle track. "We rode horses to school," recalled Jesse Lasky Jr., son of the movie producer. The town's one policeman stood at the corner of Hollywood and cobblestoned Vine Street. Streetcar signs read "Don't Shoot Rabbits

from the Rear Platform." Troupes of gaudy film actors would arrive into this scene, blinking in the sunlight and rumpled from five days on the train. Shunned by the theatre world, they were met with disdain by local puritans. The "movies" were regarded as any other ragtag pack of rambling carnies might be — as shiftless, faithless, and immoral. They lived in a world of artifice and illusion. They proffered fake-looking paper money in a time when gold and silver was the West's currency. And trailing in their wake came some of the more determined Patent Warriors — Edison's hired thugs.

In Southern California, recalled director Allan Dwan, "we were watching the depot constantly. I had my three cowboys arm themselves, hire some other cowboys, and station themselves outside our area of work." When Cecil B. DeMille arrived to shoot *The Squaw Man* in 1912, he had a huge revolver in his luggage. After receiving a note which read "Fold your studio, or your life won't be worth much," DeMille wore the gun at his waist for all to see. One day he was fired upon by patents agents as he travelled from home to the converted barn that was his studio. He hired a wolf for one picture and kept it around for security. Unfortunately the wolf was at home with him on the night a gangster broke into his studio and burned the negatives.

The work itself presented another bizarre spectacle. Everything was shot outside on a forty-by-thirty-foot outdoor platform. On the platform stood furniture — overstuffed chairs, carpets, cabinets, a bed — though these were mostly hidden from sight by muslin curtains on pulleys, designed to diffuse the harsh sunlight. Great gusts of wind blew through these interiors. The directors and cameramen in their city-slicker clothes were almost as freakish as the silent-film actors, who

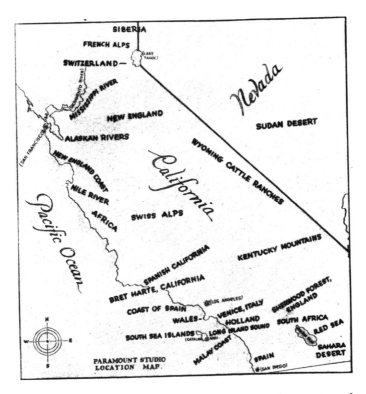

A Paramount Studio location map of California. Different parts of the state are labelled according to their similarity to some distant place. COURTESY PARAMOUNT PICTURES

were made up chalk white (the film stock of the time made pink Caucasian skin appear virtually black), their eyes and lips smudged dark for emotion. Directors hired violinists to play romantic airs, provoking the actors to new heights of passion. Filming created chaos in the streets, angering the townspeople. "Say, you don't own this street!" they cried. Griffith hired some ex-prizefighters as protection. NO MOVIES read the classified

ads for lodging. It was difficult for them to find room and board, let alone credit, so they tended to stick together. They had to make their own fun in this primitive village. This did little to improve their reputation among the "private people." Even their children were scorned. "I knew about racial discrimination," recalled Agnes B. de Mille, Cecil's little niece, "because I was a 'movie.'"

The social isolation of the film people together with the geographical isolation from New York City helped to create a communal atmosphere among them. It helped to make a film colony. The colonists were also united by an ideal: the pioneering of a new art form. Of course they wanted to make money too. But in those early years, motion pictures were not especially lucrative — scenarist William de Mille for one insisted that there would never be any money in them — and the business was experimental and provisional. The gold rush was yet to come. A sense of possibility pervaded the movie world, nothing more, but the film colony was increasingly animated by an aesthetic ideal as Griffith in particular assumed a new urgency of purpose.

Accustomed to the endless touring of theatrical companies, the actors were glad of a chance to stay put for awhile. The film community had all the camaraderie of a theatre company as well as a degree of stability. "It was like a family," remembered the actress Viola Dana. Like a family, the movie pioneers shared a single dwelling — most of them lived at the Hollywood Hotel. This great rambling structure was managed by a prim lady called Mrs. Hershey, who tried to ensure that residents stayed in their own beds. Though they had to rise in the small hours for work, the film folk still found time to linger in the

dancehall late into the night. Actors and actresses, dressmakers, stuntmen, directors and cameramen, writers, carpenters: they danced, ate, lived, sang, and worked together. Many of them wore several hats. Edwin S. Porter, for example, served as president, cameraman, and electrician of his company. Few social distinctions existed in the days before the stars and their barrels of money. "Nobody was a great star then," recalled Charlie Chaplin in 1966. "There were no great moguls. We liked the freedom of it . . . the simplicity of it. We all did our job. If there was no sun, or we were tired, we were all very happy to think it was a nice dull day and we didn't have to work. It was very romantic."

Movie work was open and spontaneous in the days before sound. An impulsive, noisy spirit reigned on set. As the camera turned, the air was full of sound. Most companies used violinists, many had small orchestras, and Griffith was among those who used a brass band during battle scenes to whip up the actors and synchronize their movements. There was chatter, the director calling out encouragement to the actors. He could talk them through each scene, coaxing, cueing, and correcting. And there were scarcely any rules on set. Stuntmen — carnies and cowboys — vied with each other to effect the most bloodcurdlingly risky tricks. (Buster Keaton, who was born during a Kansas tornado into a family of vaudeville acrobats, was famous for his daring stuntwork.) Extras were pulled out of the crowd of spectators and hired on the spot. Griffith spoke of the early Biograph days as "the most picturesque since Molière or Villon . . . there was the freedom, the change of scene, the coursing about the countryside as Romans, pirates, royalty, great lovers and great villains." Typically companies made two movies per

week, one Western and one non-Western. By night they would project the day's work on someone's livingroom wall, inviting the whole neighbourhood. As one resident recalled, "There was a strong communal sense. Local families would be invited in – 'come in, come in and see our picture.'"

One friendly neighbour was L. Frank Baum. The Baum family home, Ozcot, lay close to Sunset Boulevard on what is now Cherokee Avenue. Baum had retired to Hollywood in 1909 and soon found the ideal world of his imagination springing up around him as if by enchantment. Extravagantly costumed figures ambled casually in the streets. One local wrote that at noontime when the parks filled up "you were apt to see Bluebeard and all his wives cosily eating ham sandwiches and hardboiled eggs, while the Apostle John sat under a pepper tree with his arm around a bathing beauty." Pastoral yet technologically sophisticated, innovative, bohemian yet innocent, Hollywood's film colony was a fairyland to the author of *The Wonderful Wizard of Oz*.

Baum joyfully started a studio of his own and threw himself into the task of forging a social life for the film colonists. Ozcot was one of Hollywood's first remarkable houses and soon became a centre of movie colony social activities. Built in an exotic "Japonesque" style, it stood out among the simple frame houses of Hollywood. A path led from the back door into a lush garden. Baum constructed an enormous circular aviary there and filled it with different sorts of plumed and colourful songbirds. There was a lily pond with goldfish and a fountain. There were crimson peonies and bright chrysanthemums which won prizes in local competitions, earning Baum the title "Chrysanthemum King of Hollywood" several years in a row. With Will

Rogers and other movie notables he helped to found the Uplifters, a social club which put on theatrical entertainments for the isolated movie people. Clubs like the Uplifters cheered the new Californians and bound them together as a group. Baum helped to make a camp into a community.

Hollywood's sense of itself also grew through a delicate feedback system with the American public. Biograph's weekly one-reelers had sparked an intense new adulation: letters were pouring in addressed only to "the Biograph Girl," "the Girl with the Curls," or "Goldilocks," who appeared in pictures like *The New York Hat* (1912), written by a diminutive young Californian named Anita Loos (she later wrote the novel *Gentlemen Prefer Blondes*). They could not know, these lovers of all ages and from all walks of life, that the Biograph Girl's name was Mary Pickford. How could they? All the Biograph players were anonymous. Determined to keep her salary down, Biograph burnt the letters as fast as the fans could write them. The phenomenon soon outran Biograph's control however. Through a mysterious celluloid alchemy, a canny Torontonian with heavy dark-blond ringlets and square little teeth, so quaint and remote to our eyes, became the animating spirit of the age. The first movie star was taking shape. Pickford is not associated with any one picture. Her persona — wistful and soulful, beguilingly spunky, an orphan — lived in the public imagination. All across the country, people flocked to the movie theatres to see "America's Sweetheart" light the screen.

Southern California had produced something new. As an innocent place-name — Hollywood — became metonymical for a region, an industry, a people, a mode of living, California's mythology quickened. It gained heft and density; it gained

presence. Companies like Biograph, which had only wintered there, now resolved to stay for good. California was indeed the seat of a new civilization, one without, as the contemporary historian Gilbert Seldes argued, a counterpart in Europe or the ancient world. It was uniquely of and about the twentieth century. No other fine art, none of its six elegant sisters, was so popular in origin, and none presupposed such technological finesse. Hollywood went on, in endless plays of scale, to represent and to encompass the earth's four corners, and its history has been the dream history of the twentieth century. We are all inhabitants of Hollywood town today.

~

D.W. Griffith was swift to pick up on the import of film's new power. His shame gave way to pride and excitement. One day on the Biograph set, he flew into a boiling rage when he overheard some player casually utter the word "flickers." "Never let me hear that word again!" he shouted. Drawing himself up and fixing the assembled company with a burning gaze, he held forth on the dignity and power of film. This was a novel concept. The director who had poured scorn on motion pictures now extolled them. "Do you know," he told them, "we are playing to the world! What we film tomorrow will stir the hearts of the world — and they will understand what we're saying. We've gone beyond Babel, beyond words. We've found a universal language — a power that can make men brothers and end war forever. Remember that. Remember that, when you stand in front of a camera!" Griffith made disciples of this motley band of players. "We weren't for the Biograph Company," as the actress Blanche Sweet put it. "We were for Griffith."

If the Babel story depicts a second Fall of Man, the Universal Language offered redemption, a recovery of prelapsarian possibilities. Griffith began comparing movies to Esperanto, the artificial language created by a Polish oculist who called himself Dr. Esperanto — "one who hopes." What he hoped was that his created language, because it would belong to no nation and every nation, would unite the world. Cinema was for Griffith and his followers an "Esperanto of the eye," a pure new language free of the cultural taint and slant of English, French, German, Swahili, or any other tongue (see "Beyond Babel" for a fuller discussion). As nations geared up for world war, this idea gained urgency and currency. Behind the utopian vision of the Universal Language lies the belief that war derives from miscommunication: violence as the failure of speech. Griffith, who grew up in the aftermath of the American Civil War and whose mind was shaped by it, believed that the South was simply unable to articulate its perspective to the North — for the language barrier also extended to fellow-speakers of English. Miscommunication was a function of words, whereas the Universal Language of silent film was uncorrupted. "Silence ... becomes more eloquent than all the tongues of men," said Griffith. The Universal Language transcended frontiers. It could make of the divided earth a peaceful commonwealth. Hollywood would be the capital of this new utopian realm.

Lillian Gish was its figurehead. Whereas Mary Pickford was always a bit skeptical of Griffith (she soon left Biograph in a dispute over money), Gish was his most fervent follower. Anita Loos remarked that Gish was more devoted to the movies than anyone, even Griffith. Gish wrote that the director "taught us, as children, that we were taking the first tiny steps in a new

medium that had been predicted in the Bible and called the Universal Language. That when it could be brought to its full power, it would bring about the millennium. Since it broke down the barriers that many languages create ... properly used, it could bring peace to the world." Gish observed that Griffith had written "on celluloid a new formula that would cure the world's ills." Supplemented by music, cinema would heal humanity. Gish devoted herself body and soul to this shimmering mirage.

Gish and Pickford, lifelong friends, were the twin princesses of Hollywood in the early years, with plucky and realistic Pickford playing Dorothy to Gish's ethereal Ozma. Lillian's porcelain features — scarcely corporeal in their pale fragility — incarnated more than any other thing the exalted idealism of Griffith's Universal Language. It was a language of emotion, seeking to express much with a minimal use of intertitles slipped between images. The silent-screen player had to tug at the heartstrings and draw the audience in. Silent film requires full attention. Viewers are watchful, engaged, following closely as if in a curiously deep game of charades. Movie acting demanded immensely expressive eyes, eyes to engage the viewer in a passionate reading exercise.

With her huge long-fringed eyes, Gish was intensely communicative. For Griffith she projected a vulnerable perfection. Gish is a wavering flame, an ideal under threat. Like an allegorical figure of Virtue, she presents an abstraction. Gish stands for communication itself. She is a kind of human olive branch representing the peaceful side of human nature, a quality made all the more valuable by its fragility. As Europe went to war in 1914, this ideal seemed more desirable and more elusive than ever.

As Europeans marched into battle, Griffith was recreating the American Civil War in Southern California. While the roads and fields of Europe flooded with soldiers, the hills of Hollywood were filled with extras who had been rounded up and thrust into uniform. Griffith was filming *Birth of a Nation*. Based on William Dixon's novel *The Clansman*, it was the most ambitious production mounted to date. The explosives alone probably cost more than the average Biograph picture. In addition to soldiers, there were horses, carriages, actors in blackface ("there were practically no Negro actors in California then," Gish later explained), and Southern belles in voluminous dresses. Hollywood had never seen such a grand production.

Lillian Gish was cast as Elsie Stoneman, the pure-hearted daughter of a corrupt Northern politician sent in to govern the postbellum South. As a Northerner with Southern connections — she nurses a dashing Southern officer, falls in love, and befriends his sisters — she represents a bridge between warring parties. As such, she is stretched painfully as on a rack. Here, as in *Broken Blossoms* (1919), Gish portrays a kind of sacrificial lamb, saintly in her sufferings for humanity. Embittered Southerners reject her; her carpetbagging father humiliates her. Elsie, in her way, is as much a virtuous communicator as Lincoln, who is portrayed sympathetically. Lincoln's assassination comes across as the nail in the coffin of North-South relations. Griffith felt that nothing short of the Universal Language could reconcile the fractured halves after that.

Birth of a Nation was an unparalleled success — but it hardly ushered in a new age of peace and understanding in America. It was received with an intensity never before accorded to a motion picture. When it premiered in Los Angeles on February

8, 1915, it was accompanied by a forty-piece orchestra and a large chorus. During the film Gish looked around and was struck to see tears streaming down the cheeks of men and women sitting in the theatre. After the final shot depicting Christ with a message of peace, the audience members leapt as one to their feet and applauded passionately. Joseph Henaby, who played Lincoln, later in life declared that he had "never heard at any exhibition — play, concert, or anything — an audience react at the finish as they did at the end of *Birth of a Nation*. They literally tore the place apart. Why were they so wildly enthusiastic? Because they felt in their inner souls that something had really grown and developed — that this was a kind of fulfillment." On tour, on the other hand, it was met with passionate *anger* by many. The National Association for the Advancement of Colored People (NAACP), already a prominent organization, hated the film's depiction of blacks. It issued a pamphlet entitled "Fighting a Vicious Film: Protest Against *The Birth of a Nation*." Crowds did protest, and sometimes the protests turned violent. Other people aggressively endorsed its white-supremacist overtones. Many critics denounced the film's politics even as they celebrated its artistry. Far from ushering in a new age of peace, *Birth of a Nation* created turbulence everywhere it played. Griffith was dismayed. But Americans could agree on one thing: movies were to be taken seriously now. The flickers could be fine art. And all kinds of people could appreciate them. In addition to straddling the language barrier, the movies also broke class lines.

Lillian Gish in Way Down East, *1920. Gish was devoted to D.W. Griffith and the cinema.*

~

D.W. Griffith, Charlie Chaplin, Douglas Fairbanks, and Mary Pickford were the most influential figures in the limitless new realm of Hollywood. Griffith was admired and Chaplin and Fairbanks were loved, but the queen of dream life was idolized. Her hair in particular was worshipped as a relic. These deep gold tresses were as valuable and as burdensome as a crown. In the days when only children wore their hair loose in public, and a woman with loose hair signalled bedtime, "Little Mary's" ringlets suggested innocence *and* eroticism. Moviegoers groaned aloud when anyone cut a lock and cried out indignantly when any man saw fit to touch the hair on screen. Such a character usually received a quick retaliatory slap from Little Mary. Her worshippers would have been horrified to learn that the sacred hair was topped up with long ringlets purchased from a local establishment, Big Suzy's French Whorehouse, at $50 apiece. Pickford regarded her crown of hair with ambivalence and was often seized by a desire to chop off "this gold chain around my neck." But she knew that her power lay in her luminous hair. "I think shorn of them I should become almost as Samson after his unfortunate meeting with Delilah," she observed.

Pickford's royal inflections conveyed a keen sense of her public role. America's Sweetheart never made an important decision without considering "her people," realizing that "the Little Girl" belonged not to her but to her subjects. The childlike mask had to be handled delicately. She agonized over the decision to divorce her first husband and marry Douglas Fairbanks. What would a controversial remarriage to another famous

Mary Pickford, circa 1915. "America's Sweetheart" was born in Canada.

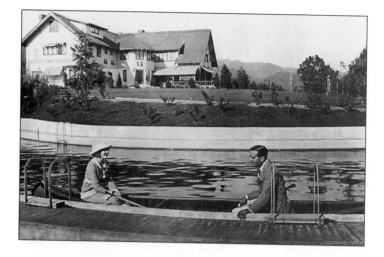

Mary Pickford and Douglas Fairbanks at Pickfair, early 1920s.

movie actor do to the Little Girl? "I can see her now," said her friend, the writer Adela Rogers St John. "'Adela,' she said, 'if I divorce Owen and marry Douglas Fairbanks, will my people ever forgive me?'"

Fortunately they did. In fact the union had the effect of shoring up Pickford's power. The Little Girl was left miraculously inviolate, while Mary's business empire continued to grow. (One studio head declared he would rather deal with a team of ruthless bankers than with Mary and her mother. Chaplin for his part nicknamed her, to her profound irritation, "the Bank of America's Sweetheart.") The boyish and acrobatic Fairbanks was seen as her ideal consort. California's Peter Pan and Wendy ruled Movieland from Pickfair, their mansion in the Hollywood Hills. It was often referred to in the Hollywood press as the Second White House. At the centre of a limitless

new jurisdiction with potentially limitless citizenship, Pickfair represented the movies' new legitimacy. Everyone wanted in to Movieland. "Doug and Mary" entertained the King and Queen of Siam at Pickfair. Albert Einstein paid a visit. The Earl of Mountbatten, a frequent guest, declared Doug and Mary to be the "great unifying force" of ragtag Hollywood. Their state visits to England and Russia brought out vast impassioned crowds.

Hollywood knew no borders. It was a space which could be entered through portals in every town across America and increasingly throughout the globe. The wretched nickelodeons were reborn as spangled dream palaces, with tapestries, chandeliers, rugs, gilt, domes, pillars, orchestras, and armies of ushers. Samuel L. "Roxy" Rothapfel had started his first movie house behind a saloon, renting 200 chairs from an undertaker. He went on to open the Paramount in New York City, a luxurious theatre complex where patrons could choose from among ten themed rooms, including an Elizabethan room, the Chinoiserie, the Venetian room, the Empire room, and something called Peacock Alley. As the outposts of movieland drew crowds and the money rolled in, actors and producers erected fantastical mansions all over Los Angeles. These were scarcely distinguishable from the opulent new sets that materialized here and there, only to vanish once the film was done.

Movieland soon eclipsed the farming village and eventually sent the Krotonans packing — the pure and isolated town they once knew had vanished, so they moved to Ojai, a quiet valley some eighty miles north of Los Angeles. The abstemious farmers of Hollywood saw their worst nightmare literalized in the massive Babylon set for Griffith's *Intolerance*. Keystone Kops charged across their yards, wild animals escaped from studio

zoos and rampaged through town, and a fake blizzard created a whiteout in the business centre. Thousands of young aspirants were arriving each year, sparking anxiety in parental hearts across the country. Foreign hopefuls came as well, since broken English was no impediment in the Universal Language. Subsidiary industries for props, costumes, and equipment – the whole range of dream machinery – fanned out around the new studios. A cinematic city emerged.

California offered an intensification of the rags-to-riches scenario. In California, as Robert Sklar writes, "beginnings have almost no place," and immigrants could consign their roots to oblivion and project upon the silver screen of Hollywood "a Platonic conception of themselves." This fantasy could extend across the classes, from humble Jewish businessmen to the scores of Russian aristocrats who were homeless and penniless in the wake of the 1917 revolution. Their positive desire to appear on film speaks volumes about the motion pictures' new-found glory. (Carl Laemmle, the president of Universal Pictures, even cabled a formal invitation to Tsar Nicholas and his family to come to Hollywood and become movie actors.)

～

When we mourn the Silent Era, we mourn among other things the "universal city" of Hollywood itself – a truly cosmopolitan, polyglot town. A new internationalism reigned there, intensifying in the wake of the Great War. Hollywood's postwar success – 80 percent of films shown abroad were now Hollywood films – was not only an American triumph. D.W. Griffith had resisted sound films – "the talkies" – arguing thus: "Only 5 per cent of the world speak English. Why should I lose 95 per cent of my

audience?" With the introduction of sound, however, these others adapted. The dissemination of Hollywood movies became more closely linked to specifically American ambitions worldwide. Hollywood has contributed in no small measure to the present worldwide dominance of English.

American English cadences eventually drowned out the Universal Language. The studios were not especially quick to switch to the new technology because it required a big investment in equipment and a massive adaptation for everyone involved in production. But audiences had begun to dwindle somewhat by the mid-1920s, and the studios needed a novelty to bring the people back. The thing that convinced them to change was the phenomenal success of *The Jazz Singer* (1927), an experimental talkie starring Al Jolson in blackface. Then 1929, the year of the stock market crash, sealed the fate of the silents. Fox announced it was ceasing production of silent movies in 1929, and one by one the other studios fell into line.

Sound spelled disaster for many foreign actors, and many careers hit the skids. Charlie Chaplin was one of the few powerful Hollywood figures to hold out against sound, "loudly denounc[ing] the talkers," as one commentator put it in 1929. An atmosphere of anxiety settled over the colony. The relaxed ethos of the studios evaporated. Actors were terrified lest their voices didn't translate well into the new medium. The introduction of sound took much of the fun and spontaneity out of shooting, since quiet was imperative during takes. As Barry Paris put it, "When silence went out of movies, it came onto the set." The on-set orchestras were thrown out of work. Directors could no longer talk actors through the scene, leaving the actors feeling strangely isolated. They were also miserably

uncomfortable, since soundproofing made the studios airtight; under the powerful new lights they were obliged to wear rubber suits beneath their costumes so that they would not be seen to sweat.

The loss of the Universal Language goes some way to accounting for the deep aura of melancholy hanging over the silent era. This is usually explained, albeit poignantly, in terms of lost careers and livelihoods: the ranks of actors and actresses who were mocked and forgotten when their voices tested too foreign, too lowly, or simply too irritating. There are stories of crowds of musicians forced onto the bread line when sets went quiet and cinemas brought in the talkies. What is so often overlooked, though, is the fact that a whole new art form abruptly vanished, taking with it the fragile vision of a language beyond words and beyond borders. Suddenly obsolete, the world of the silents sank like a stone and lay submerged, an Atlantis, in memory. Lillian Gish felt this loss more sharply than anyone. She was bitter, lamenting the fact that the movies had "married words instead of music." She blamed the fickle public. "The public has a newer and better toy," she declared witheringly in 1929. "Give a little girl a doll that walks and she's delighted. But give her one that also says 'Mama,' and she is entranced. The talkies say 'Mama.'" Gish continued to work, enjoying a modest success in the talkies. But she never stopped agitating for the silents. As a roving ambassador of a lost world, the Atlantis that is silent film, she continued writing and lecturing about Griffith's vision until her death in 1993. She also never lost touch with Mary Pickford, who did not fare so well in the era of short hair and sound. Though Pickford's new bob made the cover of the *New York Times* in 1929, it also robbed her, as

foreseen, of her power. "The Little Girl" was irretrievably *passé*, and the few talkies that she made failed to impress her people. They moved on, and Pickford withdrew into Pickfair and an alcoholic haze.

Pickford was an inspiration for the character of Norma Desmond, the neglected silent-screen goddess of *Sunset Boulevard* (1950). A whole new Hollywood had grown up around Pickford while she dozed oblivious in her fortress, a movieland which scarcely remembered its origins. Hardboiled 1950s Hollywood could hardly recall a time when it didn't exist. Billy Wilder's film was a revelation, an extraordinary archaeological exercise. Wilder actually offered Pickford the part before showing the script to anyone else. But Pickford had never been famed for a wry sense of humour. She wanted Norma Desmond to be a more dignified character and drew up a list of changes. The part then went to the more resilient Gloria Swanson, leaving Pickford to slumber on unmolested, dreaming of a time – ancient history, in our culture of forgetfulness – when she was queen of a new enchanted landscape. Sometimes, when the magic hour lends its sunset glow to the raddled city, we can still see it like that.

Three

A Glistering God

Golden lads and girls all must
As chimney sweepers, come to dust

<div align="right">SHAKESPEARE, CYMBELINE</div>

Kenneth Anger tells us — and herein we find the seeds of *Holly-wood Babylon* — that when the notorious warlock Aleister Crowley visited the movie colony during his 1916 travels on the West Coast, he found it to be an oasis of drug-addled sex fanatics. This may have been wishful thinking on Crowley's part, for the *soi-disant* Black Beast tended to see mayhem wherever he cast his bleary eyes. But the uncanny image has some truth to it. Crowley's description hints at the sheer improbability of a place where the huge Babylon set for *Intolerance* towered over a rustic landscape until it was finally condemned by the fire department, and where the world's biggest weirdoes, city slickers, and sophisticates lived alongside simple farmers, with little in between. It was a landscape of puzzling juxtapositions. To the naked eye, Hollywood was farmland, hill after hill of orange, avocado, bean, and poppy fields, but increasingly it concealed secret gardens, little bohemias, worlds within worlds.

In the late Teens, then, little bohemian circles were springing into being — some planned, others fortuitous — which sought to articulate the potential of this new culture. D.W. Griffith and Lillian Gish were by no means the only artistic idealists in Hollywood, by no means the only ones to envisage movies as the art form for the new century and, as such, a potentially redemptive force in the world. The idea of movies as uplifting or "improving" sounds strange to our ears. Today we often hear that Hollywood movies merely hypnotize and corrupt us, so it is striking to read Griffith's claim that cinema reduces drinking because "the motion pictures give a man a place to go beside the saloons," or that children should watch lots of movies as part of their education. "If I had a growing son, I should be willing to let him see motion pictures as much as he liked," he mused in one interview, "because ... they would shape his character along the most rigid plane of human conduct." This makes movies sound rather like bitter medicine, but it is worth noting that much of the audience was complicit with this idea of uplift. People considered, for example, that Hollywood had improved homes, dress, and health. As one fan wrote, expressing a typical sentiment: "The movies are urging us up out of vulgarity. They are bringing to the people culture, a virtue considered before impossible to obtain."

Certain people in Hollywood went a lot further than trying to effect a little improvement or cultivation. They saw in California the power to restore lost human potential — a loss they described variously in terms of the Fall, Babel Tower, the Golden Age. Griffith's high hopes for cinema were shared by others of a far more esoteric bent. His idea was that movies could prompt moral improvement by showcasing purity and

innocence. Others, such as the Valentinos — Rudolph and his flamboyant wife, Natacha Rambova — as well as the influential scenarist June Mathis and, more peripherally, the extravagantly posing Russian actress Alla Nazimova, saw erotic beauty as spiritually ennobling. This quartet formed the nucleus of a local group linked with what was then known as New Thought: the fusion of American self-help, occult theories, and Eastern mysticism that is currently termed New Age. Natacha Rambova had links to Katherine Tingley's Theosophical realm at nearby Point Loma. Far from being a mere *divertissement* for these movie pioneers, New Thought — specifically in the form of Spiritism and its offshoot Theosophy — was intimately bound up with their sense of artistic purpose. New Thought, with its peculiar vision of California, stands as a foundational stone of Hollywood. Theosophy in particular complemented the nascent Hollywood star system.

As we saw in "Emerald Cities," California, the final repository of all westward-yearning hopes, all the deferred dreams of the ages, was for Theosophy the foreordained site of a splendid new civilization which would surpass all others. It would echo the ancient cultures of Mexico and relegate Europe to oblivion. This vision of the westward land entailed — and still entails — fervent hopes for a recovery of human potential lost with Eden. It would be the fullest expression to date of humanity's latent divinity: each human being had the potential to become a god. The Masters, spirit entities, occupied a high rung on the ladder of enlightenment; a god represented the fullest flowering of a human soul. The arts — especially theatre, music, dance, and design — were privileged by Theosophy insofar as they were seen as a stretching towards the divine level, hence the focus on

music, dance, painting, and drama at Point Loma. Cinema could fit very neatly within this paradigm. It was to be the twentieth-century art *par excellence*, heralding and ushering in a new order of things. Cinema, "the Seventh Muse," stood as a new art form for a new civilization. As the Universal Language, it was also this new civilization's official tongue. Cinema coincided with a new era, and its actors might offer a beacon to all humanity.

Such a studied view of California's destiny, this majestic idealism, naturally jostled at times with a frontier or gold-rush mentality. Most movie colonists were animated in varying degrees by love of money, notoriety, pleasure, and adventure. The movie people shared the popular notion of California as a kind of paradise, but the idea was articulated by New Thought in a far more self-conscious and specific manner. These people – Theosophists and others – held that the historical stage was set for a large-scale retrieval of Golden Age potential. They agreed with Jews and Christians that humanity had lost something, but differed over prospects for recovery. Theosophists were optimistic that human nature could be restored in this life. A new epoch, the Age of Aquarius, was coming to renew the tired world. California was the perfect setting, an environment which was salubrious enough to help coax out humanity's latent divinity. California's paradisical aspect would remind human beings of who they really were. The sun-soaked Californian dream and the exciting potential of the new medium of film were quickly intertwined and grafted together, soon becoming inextricable. What bears emphasis here is the degree to which certain film people became imbued with a sense of *mission*; the prophecies related to California loaned their activities a certain

glow of predestination. Who were these missionaries, and to what degree did they influence Hollywood history?

The designer Natacha Rambova was one who had a profound effect upon Hollywood, though by name at least she is scarcely remembered today. She was Rudolph Valentino's second wife (arguably his only wife, since an earlier marriage to Jean Acker was never consummated. Right after the wedding ceremony the bride locked the groom out of her bedroom and then bolted for good). Rambova biographer Michael Morris has shown how she in effect created The Lover who went on to ravish the planet — how Rambova played Pygmalion to Valentino's Galatea, fashioning a radiant god from a rather sweet and simple man. Valentino was created by Rambova, and he died shortly after she abandoned him.

But Natacha Rambova's first major invention was her own striking self. She belongs to a class of self-created baroque personae especially plentiful in the American West. Rambova was born in Salt Lake City in 1897 — far from Moscow. She was baptized with the unromantic name of Winifred Shaughnessy and nicknamed "Wink." Her parents were distinguished. Wink's father, Michael, was a glamorous Civil War hero who had battled the Confederacy. Wounded at Gettysburg, he later helped to disband the Ku Klux Klan. Her mother, also Winifred, was a kind of Utah princess whose grandfather, Heber C. Kimball, was Mormon leader Brigham Young's right-hand man. It was Kimball and Young who decided to lead the increasingly unpopular polygamist sect out of the "Egypt" of the populous eastern U.S. In 1846 they got in their covered wagons and rolled off to pioneer what is now the state of Utah. There Kimball fathered sixty-five children by forty-five wives.

It was little Wink's special fate to be born to a mother as willful and as voraciously curious as herself. Mother Winifred was passionately interested in the arts and in New Thought, and the new century hovering on the horizon filled her with excitement. She envisioned her life moving ever upward, bristling with possibilities. Winifred soon tired of Michael, finding her middle-aged husband to be a melancholy drunk. Rather than apply himself to supporting his young wife and daughter, Michael Shaughnessy preferred to dwell endlessly on his glorious military past. The Mormon princess would have none of it. She gathered up baby Wink and ran off. Winifred would go on to marry several times, each time more advantageously than the last.

New-found wealth permitted her to send Wink off to a posh boarding school in England. She flourished there. Photographs show a ravishing young girl, tall and straight, with lovely regular features, flushed cheeks and lips, and long smooth brown hair. Wink was bright as well as beautiful. She particularly loved to study mythology and would spend countless hours curled up in an armchair with a stack of books at her side. Nothing was so enchanting to her as these traditional tales. Gods and goddesses, deities major and minor – Greek and Roman, Norse, Celtic, Egyptian, Aztec – saturated her dream life, soon spilling beyond it. She loved to read, write, and draw, but Wink's creativity first found serious expression in dance.

The Great War era was an extraordinary one for dance. The energetically Dionysian Isadora Duncan was idolized by bold young girls the world over, and Martha Graham rose to prominence at this time as well. Wild and wayward Louise Brooks left small-town American girlhood behind to pursue modern

dance. The startling modernism of Vaslav Nijinsky and the Ballets Russes under Sergei Diaghilev had given Russian dance a powerful new aura, and so when Theodore Kosloff of the Russian Imperial Ballet Company opened a school in New York, the fashionable mothers there hastened to sign their daughters up.

They might have been less eager if they had realized that the school was also in some sense a harem. The thirty-five-year old Kosloff, whose wife resided in England, helped himself to the prettiest of his students, including some who had yet to reach puberty. This unrepentant satyr soon made a favourite of seventeen-year-old Miss Shaughnessy. He gave her coveted roles in the company productions like the celebrated Aztec Dance of 1917, let her design costumes and sets, and generally aided her metamorphosis into "Natacha Rambova." The fact that she had never set foot in Russia and had not a particle of Russian blood did not trouble either of them. What mattered was the woman that name allowed her to become — cultivated, mysterious, avant-garde, even, when the occasion demanded it, rather petulant.

When Winifred learned that her daughter was living with Kosloff, she was furious. She demanded that they separate at once and for ever. Here "Natacha" emerged dramatically and defied her mother with all the fiery unconventionality she could muster. Winifred threatened to have Kosloff charged with statutory rape. This led to a standoff. Natacha went underground, fleeing to England to be housed, oddly enough, with Kosloff's wife. She remained there for six months. Finally, she offered her mother a deal: if Winifred would agree not to bring charges against Kosloff, her daughter would return to the U.S. Missing her treasured daughter horribly, Winifred capitulated.

Natacha returned triumphant to enjoy both her mother's financial support and Kosloff's company.

Far more important for Natacha Rambova than Kosloff's caresses were the opportunities he gave her for artistic expression. It was Kosloff who helped her excel at dance and design, and it was Kosloff who befriended Cecil B. DeMille, the man who would bring them both to Hollywood. DeMille was directing an Aztec extravaganza entitled *The Woman Who God Forgot* (1917), starring Geraldine Farrar as a victim trapped in the court of a frightening Aztec king. Kosloff, whose Aztec Dance had won him much praise, was a natural for the role of an Aztec prince. He could also use the money since he had gone bankrupt when, in the wake of the Russian Revolution, the Bolsheviks had appropriated his property back home. Hollywood seemed a promising prospect, and he accepted DeMille's lucrative offer. Rambova was hired to design the costumes. Outfitted by her in skimpy golden armor and bracelets which showed off his dancer's muscles, Kosloff stood and goggled imperiously at the cowering Farrar. DeMille, delighted with the Kosloff / Rambova team, persuaded them to move operations to Hollywood. There they could combine dance with movie work. The new world of motion pictures was springing up around them.

The Kosloff School of Dance opened in Los Angeles in 1918. Photographs show the owner happily surrounded by adoring young girls in tights. Fourteen-year-old Agnes De Mille, who was admitted as a favour to her Uncle Cecil, said of her dance master: "He was all male, that's for sure! But what a *ménage* of females he had around him – and mistresses!" Kosloff set about making a life for himself in Hollywood. Like many culti-

vated Europeans, he was torn between excitement about Southern California's bright potential on the one hand and nostalgia for the Old World sensibilities on the other. He searched out the company of other Russians, people who shared the special perspective of a European in the Far West — the sense of possibility tempered by the sense of isolation, of being marooned. In optimistic moods the newcomers saw California as a new Mediterranean, its warm weather favouring civilization. In darker moods it seemed to be little more than a desert. Could the desert be made to bloom? Naturally enough, the answer to this question tended to vary with people's personal fortunes.

Kosloff's quest for companions from the Old Country brought him to the doorstep of Alla Nazimova, the Russian actress at the centre of bohemian life in Hollywood. Hollywood Bohemia was a pretty sparsely populated realm at that time — most everyone knew most everyone else, and all of them knew Nazimova. Her star was strongly ascendant. She had been brought out to Hollywood from the New York stage in 1917. A *New York Times* critic, praising her "marvellously mobile" face, argued that she would be perfect for "the dumb show of the screen." The Metro studio (soon to become part of MGM) agreed and offered her the phenomenal weekly salary of $13,000, topping top star Mary Pickford's salary by $3,000. She was also free to choose her director, script, and leading man. Nazimova picked up where Theda Bara left off, specializing in dark and strutting vamps. (Theda Bara *née* Theodosia Goodman — her stage name is an anagram of "death arab" — appeared as a heavily painted and spangled Salome in 1918, and Nazimova reprised the role four years later.) La Nazi-

mova's lavish salary allowed her to sponsor Hollywood's first salon some seven years before Pickfair opened its doors.

Nazimova and her husband, English director Charles Bryant, lived surrounded by acolytes in the Spanish-style house at 8080 Sunset Boulevard which came to be known as the Garden of Alla. This part of Hollywood was still countryside in those days. Lying near the end of the Big Red Cars trolley line from Los Angeles, the property was surrounded by farmland. All manner of fruits, flowers, and vegetables were raised in these fields. Most of Nazimova's neighbours were rural types. Enchanted and excited by what might be done in Southern California, Nazimova set to work cultivating her own allotted garden. To the fragrant orange grove, dark cedars, palm trees, and lily pond she added a terrace with an aviary, a rose garden, and all manner of semitropical flowers. Poinsettia, mimosa, birds of paradise, hibiscus — everything flourished in the Garden of Alla. Nazimova spent $30,000 (a large sum in those days) on the house and grounds, finally adding a swimming pool shaped like the Black Sea.

Once Prohibition became federal law in 1919, private gathering places everywhere took on a new importance and a new intensity. The Garden of Alla became a kind of cultural hothouse in the movie colony. Weekend dinner parties attracted the likes of actress Mae Murray and her husband, the director Robert Z. Leonard, the director Robert Florey, and the actress Lilyan Tashman, as well as pianist Leopold Godowsky and his daughter Dagmar, who was friends with Charlie Chaplin, another frequent visitor. Among the regulars were the Mdvani brothers, David and Serge, who claimed to be Georgian bluebloods. David became Mae Murray's lover, while Serge married

the actress Pola Negri. Many of these guests were New Thought aficionados, people who saw art as a manifestation of spirit. Creativity and mysticism interpenetrated, and the result was that movies were conceived in an exalted atmosphere. Nazimova saw herself as an emissary sent to lift movies into the artistic realm once and for all. Her story reflects the Hollywood struggle between art and commerce – a tension which has at times been fruitful, at others, destructive. This story has been replayed in the lives of many Hollywood artists since Nazimova. People tend to be cynical about the possibility for artistic achievement in the industry town now. But in Hollywood of the very early years, nothing was set in stone and all futures seemed to be within reach.

Nazimova was working on *Aphrodite*, an erotically charged story set in pre-Christian Alexandria, when Natacha Rambova came into her life. Metro had given its shimmering star full artistic control over the movie, and Nazimova hired Kosloff to design the costumes. In reality, however, it was Rambova who did the design work, while Kosloff took the credit. When one day he was careless enough to let his mistress deliver her own drawings to Nazimova, the truth came out. Seeing the designs, Nazimova mentioned certain changes she wanted – whereupon Rambova revealed that she was the true designer and made the changes on the spot. Suddenly Kosloff was superfluous, and Rambova was on her way to independence. She had found a new mentor in Alla Nazimova, a woman who offered interesting company, a thrilling job, and a place to stay.

Rambova, spurred on by the discovery that her lover was sleeping with two of his ten-year-old students, decided to leave Kosloff for good. He didn't let her go gently. Kosloff was on a

hunting weekend at Paradise, DeMille's country estate, when his mistress packed her suitcases. He returned a few hours early. Finding her bags stacked up on the porch, Kosloff, infuriated, shot his fellow dancer in the leg with his hunting rifle. Rambova went straight to the set of *Aphrodite*, where Nazimova's young lover, a French-born cameraman named Paul Ivano, spent the afternoon extracting birdshot from her leg.

It would be a long time before Natacha danced again. She threw herself into design work, camping out at the Garden of Alla and talking heatedly with Nazimova long into the night. The sexually omnivorous Nazimova, who liked young girls every bit as much as Kosloff did, may have had designs upon Rambova. But Rambova was indifferent. Ideas, connections, opportunities – these were the things that drew her to Nazimova. It was their job, they agreed, to bring high art to Hollywood: all signs pointed to it. Unfortunately, Metro had cancelled the production of *Aphrodite* because it was deemed to be too provocative. In the wake of a Supreme Court ruling that declared movies were not fully covered by First Amendment free speech rights, many states had passed censorship laws, and Metro feared that *Aphrodite*, with its nudity, torture, murder, and lesbianism, might put them at risk of severe fines. Nazimova and Rambova were miserable; all of their hard work had been wasted. But they soldiered on. Their hopes were focused on a new project, a stylish modernization of *La Dame aux camélias*. *Camille* would of course star Nazimova as the vamp with a heart of gold, the tramp turned sacrificial lamb – but who would appear as her confused lover Armand? The answer came in the form of a snow-dusted and sweaty Eskimo who barrelled in from the next set over to ask for the part one day. This was Rambova's first sight of Rudolph Valentino.

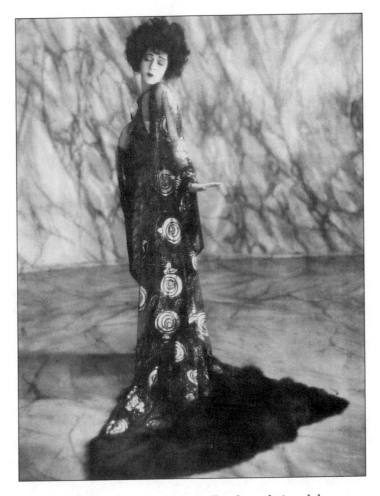

Nazimova in Camille, *1921. Natacha Rambova designed the costumes and sets.*

Neither woman was much impressed with Valentino at first. Rambova could scarcely make him out under all the fur and padding, while Nazimova had previously formed a low opinion of him. He was not famous then and was as well known among

movie people for his hustling as for his acting. After emigrating
from Italy he had worked in numerous New York dancehalls,
which had led to more lucrative work as a gigolo. His name had
been linked to troublesome women. One of his lovers was
arrested for blackmail, while another was accused of murder-
ing her husband. Valentino had come to Hollywood after those
scandals. Some in the movie world said he was a rising star, but
Nazimova had dismissed him as a "professional lounge lizard,"
a mere opportunist who didn't really care about art. She disap-
proved of him enough to have snubbed him quite savagely at
the fashionable Ship Cafe in Santa Monica. She even criticized
his looks, calling him fat and hairy. Her mind was changed,
however, by the recommendation of a woman from her New
Thought circle, June Mathis. Mathis, a former child vaudeville
player, was now a highly influential scenarist in the burgeoning
film industry. She had chosen Valentino for a feature role in
Four Horsemen of the Apocalypse (1921), which she had
adapted from the Blasco Ibañez novel. The movie had yet to be
released, but Mathis felt sure it would make a star of Valentino.
She divined a rare allure in his smooth dark face.

Valentino fell immediately, fatefully, and permanently in
love with Natacha Rambova. Rambova was queenly and culti-
vated as well as beautiful; in style as well as thought she man-
aged to be simultaneously modern and classical. While other
young women were bobbing their hair and skirts, she coiled
her long brown braids around her ears and kept her skirts at a
dignified mid-calf length. She didn't smoke in public. She was
neither old-fashioned nor a flapper, neither fusty nor frenetic —
she possessed a certain timelessness. Valentino wanted that
regal air for himself. This was the woman who could make

something of him, make him forget the dishonour of the gigolo years. He set about trying to win her, applying all of his beauty, charm, and good humour to the task. He got a boost when *Four Horsemen of the Apocalypse* was released, for it was a big hit. Mathis had been right; Valentino was indeed on his way up.

A highly charged atmosphere hung about the Garden of Alla. Love was in the electric air, and so was art, and so were the whispering spirits. They crowded close in the sweet night air, summoned forth on séance evenings to shake and sing and speak of things to come. June Mathis was particularly fond of these evenings. Mathis, obsessed by Spiritism and the obscurities of the Book of Revelation, could write only with the aid of a magical opal ring. (When another of Nazimova's friends, the actress Eva Le Gallienne, came to visit Hollywood, she divided her time between 8080 Sunset Boulevard and the nearby Theosophical colony of Krotona.) The object of the séances was not conversation with the dead *per se*, not gossip nor even consolation, but rather contact with enlightened beings who beckoned the seekers onward and upward in the quest for self-improvement — a quest seen as progressive in nature. It was at these sessions that Rambova first made contact with her spirit guide, an ancient Egyptian named Mesalope. Valentino also found his, a "redskin brave" known as Black Feather. These beings would guide them through the uncharted territory ahead: a new land, a new art form and way of life.

Rambova reciprocated Valentino's love, and their union was forged through *Camille*. Rambova, whose close relationships were always creative collaborations above all, took his image in hand. She relished the opportunity to design the sets as well as the costumes and makeup, indeed the entire look and feel of

Camille's apartment. This set, designed by Rambova, helped define the Art Deco style.

the film. In it, the organic forms of Art Nouveau are becoming more spare, more abstract, and more geometric. *Camille* (1921) was one of the first Art Deco movies. Long before the Paris Exhibition of 1925 gave a clear identity to that style, we see it in Rambova's designs. Indeed, Art Deco was the first design to develop and spread in tandem with film. And thus it became in some sense the style of the new Californian civilization. Filmed almost entirely indoors, *Camille* featured a striking, fantastically abstract Paris apartment set where pure rounded forms are everywhere repeated – wide archways, circular furniture, a strange sphere for a fireplace. In the long looping swirls of Nazimova's black-and-white gowns and tall coiffure we see the influence of Aubrey Beardsley's Decadent ink illustrations. In

Valentino's staring, burning Armand we see The Lover in embryo. *Camille* introduced a new elegance to Hollywood movies. It was received moderately well by critics and the public, but Metro declined to renew Nazimova's contract. Rather than signing with another studio that might restrain her artistically, Nazimova resolved to produce her next movie independently. She announced to an attentive press corps that she would be producing only films of supreme artistic merit. Like Griffith, Nazimova was eager to demonstrate that cinema should be ranked alongside the fine arts. (Her artistic vision was avant-garde, however, while his was more traditional.)

Among the first of these independent productions was a movie version of Oscar Wilde's *Salome* (1922). Nazimova's choice of Wilde constituted an artistic manifesto in and of itself. Wilde, whose melancholy story of hard time in England and painful death in France was still fresh in memory, stood for something: high aestheticism, artistic and sexual martyrdom, and a tempting brand of utopianism (in *The Soul of Man under Socialism*, Wilde imagines a future in which humanity is set free by machines to dream and play and be gloriously idle. The machine age would make artists and aristocrats out of everyone). Nazimova declared herself in choosing Wilde. Moreover, the play she chose is provocative and risked displeasing audiences – for Wilde's emphasis in *Salome* (1894) is erotic rather than moral. Wilde adds to the sexual elements of the Bible account by making Salome infatuated with St. John the Baptist, and Herod boiling with lust for Salome.

The fevered atmosphere of the play is precisely portrayed in Aubrey Beardsley's sumptuous, vaguely queasy illustrations, which are echoed in Rambova's phantasmagoric designs for the

film. Her costumes and sets surpassed the rest of Hollywood in terms of sheer dream-world bizarreness and whimsical artifice, making *Camille* look like simple homely realism by contrast. The world of *Salome* bore little resemblance to ancient Judea, suggesting instead a fusion of fairyland with the most out- landish reveries of Caligula. To forestall the censors, Nazimova held advance screenings and polled audience members about the worthiness of the film. People were impressed. Asked on a questionnaire whether they thought that "*Salome* realizes or forecasts the greater possibilities of the motion picture as a medium of art," 151 of 182 respondents ticked the box marked "yes." Natacha Rambova's hard work was paying off.

It gave her just enough income to rent herself a little duplex at 6612 Sunset Boulevard. When her mother and stepfather passed through on their way south in 1921 (Mother Winifred was now a practising Theosophist, devoted to Katherine Tin- gley and Point Loma) they found her living a bohemian idyll with an Italian actor. Mrs. Hudnut was both alarmed and impressed by what she saw. She initially mistook the bungalow for a garage. "The front room was quite large enough for four people if you happened to edge in right," she later reported. "The rug, a creation of the most brilliant modern colors and design, was painted on the floor. Four kitchen chairs, lacquered in red, a small comfortable sofa covered in bright modern chintz, two small sofa tables which held lamps with gay paper shades, book cases which had originally been packing boxes but now transformed by red paint into things of beauty, com- prised the unique furnishings of this room." Winifred was proud of her daughter's innate stylishness. She was less com- fortable with her daughter's strange collection of animals.

Winifred found a half-grown lioness, Zela, snarling in the bath-tub. (When she got older, the lioness often escaped through the window and wandered down Sunset Boulevard by night.) There were also a German shepherd, two Great Danes, a green moss monkey, and a huge gopher snake to contend with. Nazimova's ex-lover Paul Ivano was more or less permanently encamped there as well.

But Valentino put the Hudnuts entirely at ease. It was the happiest period of his life, and he radiated sweetness and gracious hospitality. He had found the woman of his reveries, and although he was still quite poor by Hollywood standards, Metro having failed to give him a raise in spite of the success of *Four Horsemen*, wide landscapes of possibility were suddenly opening up. He was full of hope for the future. He had a small but growing fan base and was living mostly off the quarters people sent him in exchange for signed photographs. Much of their food came free, gathered at the seashore and occasionally scavenged from nearby farms. Valentino loved to prepare big spaghetti dinners for Natacha and their guests. Warm and friendly while she was aloof, simple while she was sophisticated, Valentino served as the perfect foil for Rambova. Winifred Hudnut came away feeling confident that her daughter had found the right man and a suitable milieu. She was gratified as well by their interest in New Thought.

This private pursuit went public in 1922, when the Valentinos began work on *The Young Rajah*, which had been adapted by June Mathis from a novel by John Ames Mitchell. The story concerns a Harvard student, Amos Judd, who learns that he is really the long-lost son of the Maharishi of Dharmagar. This Krishnamurti-esque figure is gifted with psychic powers: he

can periodically see into the future, experiencing a burning sensation on his temple before a vision of future time. As a Hindu prince he appears in wildly decorative costumes, including one which was composed entirely of ropes of pearls. Just like this character, Mathis, Valentino, and Rambova openly sought guidance from the spirit world as they worked on the project. This was a great source of annoyance to the director, Philip Rosen, who complained to Paramount about being ordered around by "a bunch of spooks." It was virtually impossible to argue with the New Thinkers, since they regarded their artistic ideas as supernaturally inspired and hence beyond reproach. Séances were continually in progress on the set. Mathis was loath to change anything in her scenario, which had come via the magic ring, while Rambova presented her extravagant designs as "collaborations" with Mesalope. She was more imperious than ever. As for Valentino, Rosen was forever finding him cross-legged on a table, dressed as Black Feather and communing with him psychically.

Between them they invoked a thrillingly powerful god: Eros. Rudolph Valentino was unquestionably the most potent manifestation of Eros that Hollywood had ever produced. In fact, it may still be unrivalled. A series of private photographs styled by Rambova circa 1920 are remarkable for their archetypal beauty. Valentino appears as a satyr, with dark gleaming naked skin from the waist up and furred goat-body below, delicate horns, and flute. The image owes much to Nijinsky in *L'après-midi d'un faune*, suggesting that Rambova was eager to resurrect the feral beauty of her dance idol. But there is more too – Donatello's bronze David, even Botticelli's Venus. Like a woman, Valentino twists himself into an S. Valentino, fantasized

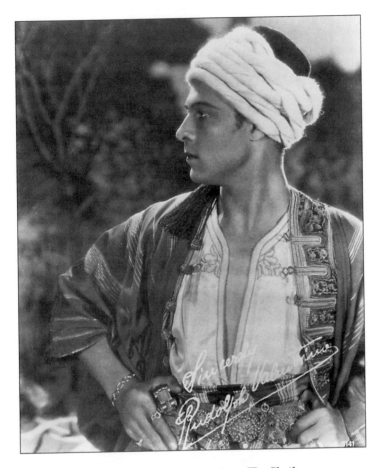

Rudolph Valentino in his trademark role as The Sheik, 1921.

into being by his wife, possessed an allure that was always androgynous. Small wonder then that he appealed mainly to women and was regarded with disdainful distrust by most men. (A writer at *Photoplay* mocked Valentino as a "he-vamp.")

Valentino infused the archetype of The Lover with the dark

shimmer of Eros. He was unfamiliar, ambiguous, otherworldly, and America was unprepared for his effect on its women — the crowds of females at *The Sheik* (1921), swooning and sobbing in the blackness. Never had audiences responded to a movie star so sexually. Never had this response been so solicited. While he lived, Rudolph Valentino inspired adoration. When he died a few short years later, in the full flower of his beauty, like a sacrifice upon an altar, he inspired mass hysteria. A number of inconsolable women killed themselves when they heard that Valentino had died from complications following surgery, and thousands rioted outside the New York funeral parlour where his body lay on a bier.

All his friends agreed he had behaved like a condemned man after his wife abandoned him. It was a contract that killed their marriage, a contract with United Artists stipulating that Rambova would no longer work with her husband. Hollywood bigwigs reckoned that she had too much control over their valuable property, and Valentino, in a fit of independence, seems to have agreed. Rambova was angry. Frustrated with Hollywood, where others had conspired to separate her from her creation, she dropped the reins and boarded a train for New York.

Her departure triggered the binge of hard living that destroyed Valentino's health and peace of mind. He began taking big risks, insisting on doing his own stunts. He was arrested for drunk driving and got in a car accident the following week. Infuriated when an anonymous editorialist at the *Chicago Tribune* blamed him for a new softness and vanity in American men — thanks to Valentino, allegedly, face-powder dispensers and pink powder puffs could be found in the gents' washroom

— the actor challenged the writer to a boxing match. No one came forward, so Valentino boxed someone else, a suitably rugged sports writer named Frank "Buck" O'Neil. Valentino fought, drank, womanized, and sped his way to a deplorably run-down state. By the summer of 1926, Rudy had developed an ulcer. It burst, and he wound up in hospital. There he underwent emergency surgery, but died a few days later from septicema. He was thirty-one.

"I do think Mrs. Valentino had a hold over Valentino," said Lou Mahoney, their handyman, "but I think it was a good hold, a progressive hold — something he needed." Without it he seems to have lost his moorings. Rambova did not attend the memorial service for her husband, even though it was held in New York. Instead, she told reporters, she held a séance with her mother and a medium. Through them, they claimed, Valentino urged his fans to rejoice. A better world awaited them; peace and happiness was his at last. Battling ex-lovers of Valentino like Pola Negri, who grabbed the spotlight with her black veils and swoons at the funeral parlour, Rambova set herself up for a time as the True Voice of Rudolph Valentino and was photographed gazing into a crystal ball. Valentino's fans do not seem to have been consoled by these messages from beyond the grave.

In any case, Rambova soon tired of this role, going on to, among other things, the world of Egyptology and marriage to a Spanish aristocrat. She came to class Hollywood with the rest of the fallen world, a world which, in the language of New Thought, she labeled "Piscean." She decided that any potential she once saw there had evaporated. A friend, Mark Hasselris, had this to say: "She called Hollywood 'Piscean', and by impli-

cation Neptunian, a watery world of glistening dream images. It not only provided entertainment, but heartache and malice to some of its participants. Beauty, she said, was distinct from glamour, and a reflection of the world's basic essence before it had been misused or distorted." Her view of the place altered with her own fortunes. Hollywood, meanwhile, was entering a new phase. Rudolph Valentino never had to face the defeat of the Universal Language and the triumph of the talkies, that new form that brought so many film divinities crashing to earth.

Looking back at the century just past, it seems that in one sense at least the Theosophists were right from the start. California has in fact become the prime locus of a new world culture — one based upon the shadow dance of spectacular mass media. As a city, as Hollywood got richer and richer it became overwhelmingly *private*, with the mansions and studios disappearing behind walls. This partly accounts for the absence of public space in Los Angeles, which so many have lamented. The average visit to Hollywood is to this day a rather disappointing experience. One is constantly confronted by walls — the walls around mansions, studios, gated communities. A tourist in Paris or Rome, roaming the streets and parks and wide piazzas, catching the slipstream of crowds, is also in those moments a citizen, a Parisian or Roman; a tourist in Hollywood is always a rank outsider. Only in the movie theatres do we become full-fledged citizens of Hollywood. In the place itself we are alien, displaced — the only Hollywood communion is virtual. It is also one that can be savoured the world over. For Hollywood is nowhere and yet everywhere at once.

Four

Beyond Babel

And the whole earth was of one language, and of one speech . . .
And they said, go to, let us build a city and a tower, whose top
may reach unto Heaven . . . And the Lord came down to see the
city and the tower, which the men had builded. And the Lord
said . . . let us go down, and there confound their language . . .

— GENESIS 11 : 1-7

The Universal Language was born in the dreams of nineteenth-century scholars, who imagined a neutral means of communication among peoples and rival powers. A single language would restore humanity to pre-Babel harmony. This utopian vision arose with the academic field of linguistics, which traced the stemming and branching of languages, over millennia, from an ancient and possibly single root. Linguists noted that native language served to divide rather than unite nations; moreover, the use of any one tongue in diplomacy seemed to privilege its native speakers — the French, traditionally, but increasingly the English and Americans. An artificial language would solve that problem. The new tongue would borrow from the major European ones — Greek, Latinate, Germanic, and Slavic — equally. Its grammar would be regular, hence "rational" and easy to master. A number of linguists set to work. Soon they had more artificial languages than they knew what to do with. Esperanto,

the invention of a Polish oculist named L.L. Zamenhof (his pen name was Dr. Esperanto, "one who hopes"), jostled for supremacy with Volapuk, Latino sine Flexione (Latin without inflections), Occidental, Novial, and Interglossa. The Americans weighed in with Interlingua. There were also two revised versions of Esperanto, one called Ido and the other Esperantido. It was Babel all over again. Ultimately the League of Nations endorsed Esperanto, dryly observing in a report which came out in the wake of the Great War, "It is in the interests of the world to have one auxiliary language, not two or three."

D.W. Griffith's Universal Language went one better than Esperanto: it dispensed with words altogether. Proud and idealistic, Griffith was determined to show that movies, far from being some crass and degrading frivolity, as many had charged, were actually going to restore mankind to its prelapsarian state. He argued that moving pictures were potentially an instrument of human redemption, and many of his followers — including the similarly quixotic Russian director Sergei Eisenstein, as we shall see — agreed. Words limited and distorted communication, whereas moving pictures were truly universal. Words were subjective and therefore ambiguous; images were objective. And unlike Esperanto, which never successfully escaped the ivory tower, movies had mass appeal. People loved the movies, adored the stars. Entertainment opened the door to instruction. "I believe in the motion picture not only as a means of amusement, but as a moral and educational force," Griffith declared at every opportunity. He resolved to make a picture unlike any other, a picture that would silence those who, while applauding its artistry, had nonetheless denounced *Birth of a Nation* as a dangerous provocation.

There was a sharp irony in the fact that the strongest propo-
nent of film as a messenger of peace and reconciliation among
peoples had made *Birth of a Nation*, which had stirred up racial
hatreds. In trying to reconcile North and South, Griffith had
further alienated black and white. Basically he had scape-
goated blacks. Griffith never tackled this problem directly,
however. Instead he offered his great Answer to everything – to
critics, to the censors who had clipped his film, to cruel oppres-
sors across time and space ("the powers of intolerance," he
termed them). *Intolerance*, a grand four-tiered epic united by a
single eponymous theme, would secure his crown as philoso-
pher-king of the new worldwide realm called Hollywood.

At every turn, Griffith made his appeal to universal human-
ity. *Intolerance* covered world history in one extravagant ges-
ture. Expanding a shorter project, a contemporary story of
poverty and injustice called "The Mother and the Law," he
added three "chapters": a war story of ancient Babylon (a
reminder of the Tower of Babel and hence the Universal Lan-
guage), the story of Christ, and the massacre of the Huguenots
in sixteenth-century France. Each story depicted the ravages of
human intolerance; all were interwoven by the use of a recur-
ring image, that of a woman (Lillian Gish) rocking a child in a
cradle. It was an image of time and of timelessness.

In the future, Griffith prophesied while at work on *Intoler-
ance*, there would be no more history books – only movies.
Past events would be re-created in consultation with a balanced
team of experts (Griffith believed that *Birth of a Nation*, for
example, was a mirror of truth), and the events of future time
would be caught on celluloid as a matter of course. The direc-
tor saw the motion picture as heroically American, a friend to

the average working man. He spoke of free speech and appealed to the American sense of hands-on practicality. Quoting President Woodrow Wilson's praise for *Birth of a Nation* ("They teach history by lightning!"), Griffith declared that Americans wanted to be *shown*, not told, history. Movies would be "the laboring man's university." With a front-row view of history, people would finally understand "what actually happened." When in the future important events were simply recorded on film for all to see, Griffith claimed, there would be no more war. War sprang out of misunderstanding and miscommunication, and the Universal Language would clarify relations between human beings. A lofty future lay ahead for the lowly flickers. Books would gather dust on the shelves as moving pictures ushered in a new age of worldwide peace. Again, the art form of the new century was yoked to Progress, the essence of modernity — human beings would *advance* because of motion pictures. "The human race will think more rapidly, more intelligently, more comprehensively than it ever did," as Griffith put it in a 1915 interview. "It will see everything."

Why was he so optimistic about the prospects for this art form? There were many reasons. Movies combined a timeless artistic form — pantomime — with technological innovation; as a result, they were both universally appealing and universally available (or at least potentially available). As his loyal disciple Lillian Gish wrote in her 1932 defense of silent film, pantomime "is the aboriginal means of human communication ... and pictures bring to a child his first acquaintance with and understanding of the world around him. The motion picture, combining the two, is thus addressed to a common human understanding." Moreover, the techniques that Griffith and his

cameraman Billy Bitzer had pioneered — the close-up, the tracking shot, the long shot, the flashback, the switchback, etc. — offered a freshly *comprehensive* quality to the illustration of human experience. This multiplicity of perspectives, temporal and spatial, on character and narrative added up to something more complete, Griffith felt, than previous art forms. In his hands the motion picture united the One and the Many: one eye, many perspectives; one director, many workers. (The great actor-director Erich von Stroheim was proud to number himself among the crew. "For you, Mr. Griffith, I work for a ham sandwich a day," he declared.)

Fittingly, *Intolerance* balanced a close attention to individual characters with colossal crowd scenes, the likes of which had never been assembled before. Each segment features a different young woman — in ancient Babylon, a fiery tomboy called The Mountain Girl (Constance Talmadge); in Palestine, the bride of Cana (Bessie Love); in sixteenth-century France, a young wife known as Brown Eyes (Margery Wilson); in modern-day America, a tenement mother (Mae Marsh). Marsh rivalled Lillian Gish in the director's estimation. She didn't have anything like Gish's uncanny, rather fey quality; her charm derived from ordinary sweetness and vulnerability. Her face was soft and mobile. She laughed, she skipped about, and her eyes shone with the kind of light that Griffith most prized in an actress. He had surmised that the new art form demanded a new kind of player. Youth was crucial for universal appeal, for every audience member had the experience of youth in common. Furthermore, close-ups were extremely revealing; a movie actress could not feign youth as she could in the theatre. A great voice was useless, and big gestures looked foolish.

Silent-film director Allan Dwan said that Griffith "developed a strange new pantomime ... Other actors exaggerated to make up for not having words. His players used short little gestures to get over their point — they were much more realistic." Eyes were the key thing. "Every other physical characteristic is of insignificant importance compared with the eyes," Griffith declared. "If they are windows of the soul, the soul must have a window it can see through." (The eyes had to be big but not blue, since blue showed up white on the film.)

Young women were influential behind the camera as well as in front of it, for Griffith liked the girlish sensibility and he liked what girls stood for — innocence, purity, and possibility. Lillian Gish and Anita Loos both worked closely with the director. Loos, one of the few native Californians in movieland, was a scenarist by trade. She sold her first scenario to Griffith in 1912 (*The New York Hat*). A tiny woman in her mid-twenties, she cultivated a schoolgirl image, dressing young and going about with her mother in tow. He kept her on, and soon she was spinning out three scenarios a week for him. She wrote most of the titles for *Intolerance* and was soon one of the most influential figures in Hollywood.

Intolerance was released in 1916. Nearly four hours in length, it was lauded by fellow directors. Intellectuals loved its breadth and depth, its sophisticated editing, its grand theme. Unfortunately it was largely ignored by the American public, who found it unwieldy and obscure. The film cost far more to make than *Birth of a Nation* — indeed, at $475,000 it cost more than *any* film had cost — yet it had a much shorter run. Griffith was ruined financially, and he never recovered his former clout with Hollywood moneymen. The experience soured him. Some

years later he told *Photoplay* magazine that directors "have to please the majority. We can't deal with opinions. All we can do is weave a little romance as pleasantly as we know how." It was a far cry from his earlier vision.

Among other things, the overwhelmingly pacifist message of *Intolerance* was out of step in 1916, the year that America entered the war. Another big antiwar production of that year, Thomas Ince's *Civilization*, suffered a similar fate at the box office. Opening with a prologue on "hopes for Universal Peace," Ince's film tells the story of a naval officer who defies orders to torpedo an ocean-liner, the *Propitania*, during wartime (an allusion to the *Lusitania* attack). The hero tears open his naval uniform to reveal a big cross, a symbol of his pacifism, emblazoned on his undershirt. He is later arrested. In the throes of a fever he travels to the Underworld, then meets Jesus Christ. The story of his court-martial and execution parallel very explicitly the crucifixion of Christ, the "Prince of Peace." Unfortunately for Ince, his movie's debut coincided precisely with America's entry into the war. *Civilization* sank like a stone.

For all that he admired the gallantry and courage of soldiers like his father, Griffith increasingly identified himself with pacifism. Peace was, after all, the main goal of the Universal Language. "Glory to hell!" exclaimed Griffith. "There is no glory in war. Every war has meant a great loss, paid by the masses." War is defined in one title as "the most potent weapon forged in the flames of intolerance," and the final sequence shows soldiers putting down their arms, together with an image of a prison dissolving into a flowery field.

Two years later the Great War was over and peace was back in

fashion. The U.S. Secretary of State, Charles Evans Hughes, set the tone for a new era by announcing at the opening of the Washington Disarmament Conference that he would scrap two million tons of battleships. Griffith suggested filming a huge naval display, ending with the sinking of the ships. A small and modestly successful Griffith production, *Hearts of the World* (1918), was shot on location in Germany. It publicized the effects of the war on the populace, who were starving. Some of the most successful movies of the Twenties were pacifist in tone. These included *The Four Horsemen of the Apocalypse* (1921) – written by June Mathis and featuring Rudolph Valentino – and King Vidor's *The Big Parade* (1925). Griffith began developing an immense antiwar project, an eight-part series of movies loosely based on H.G. Wells' 1920 work *The Outline of History*. This film would depict peace as the outgrowth of human progress, something history was leading towards. Griffith travelled to England to meet with Lord Beaverbrook and other potential investors. Wells agreed to serve on a panel of historians. The movie was never made, however. Instead it joined Griffith's lengthening list of disappointments. Griffith's hopes for the Universal Language were dying.

~

Intolerance had a short run in America, but in Russia it played by government decree for ten years solid (albeit re-edited and re-titled to present anti-Western themes). It stood as a model for the fledgling Russian movie industry. As Griffith was slowly winding down, sinking under a mountain of debt and depression, an intense young director named Sergei Eisenstein was carefully studying his work. He sat through *Intolerance* count-

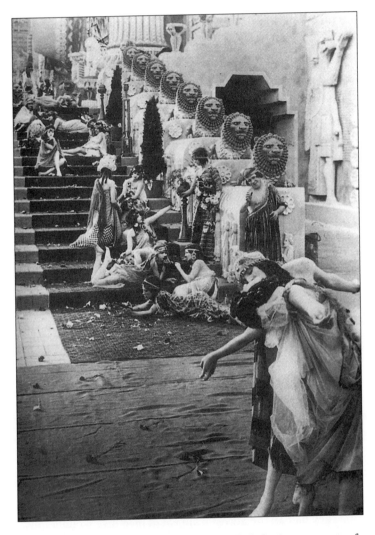

Detail of the Feast of Belshazzar from the Babylonian sequence of Intolerance *(1916).*

less times, enthralled. In fact he saw it more often than he saw any other film in his life.

Eisenstein, one of the oddest and most important figures of movie history, is difficult to classify. With a high forehead and a big woolly shock of hair, he is described as boyishly handsome by some and as a bizarre-looking troll by others. The son of a Jewish father and a Russian mother, he sometimes professed atheism, but his fascination with religious imagery and ideas came through so strongly in his films that he was eventually attacked as a Christian by fellow Communists. He was deemed a homosexual by some, but calmly denied it. In practice he seems to have been unwilling and unable to have sex with anyone at all – but was intrigued by pornography. He was an ardent Communist and patriot, but fell afoul of Stalin in the 1930s. The one thing not in dispute is Eisenstein's artistic talent. He was certainly able to build on Griffith's achievements, refining his concept of the motion picture as Universal Language. What had been vague became precise – film could constitute a language in the *literal* sense. Eisenstein spliced images together to create pictographs – "picture-writing."

Eisenstein was eager to justify Lenin's claim that "for us, the most important of all the arts is cinema." Lenin believed that its potential as a tool of propaganda was unrivalled. Eisenstein favoured movies above other media because, like Griffith, he saw them as a perfect combination of the primal and the modern. They had all the atavistic appeal of primitive iconography, yet they were the product of sophisticated technology. Finally, as they were made by a group and watched by the masses, movies were strongly collectivist in nature – and naturally this appealed to Communists.

Eisenstein knew that motion pictures were uniquely suited to speak to the masses. Building on this intrinsic quality, he set about developing montage as the syntax of filmic language. Montage — the effects created by the dramatic juxtaposition of shots — came into its own with *Battleship Potemkin* (1925), Eisenstein's first great movie. *Potemkin* recounts a Soviet historical set piece, a series of events at Odessa in 1905 which the Soviets mythologized as the first stirrings of the Russian Revolution. *Potemkin* succeeds as propaganda and as art because of the way it harnesses the moving picture's inherent quality — movement itself — to create the impression of *historical* movement, of inevitability, that is so crucial to Marxist theory. The film shows a mutiny aboard a Russian naval ship. Subsequently, a crowd of citizens who had cheered on the rebels is massacred by Tsarist troops. Eisenstein depicts the massacre in the climactic "Odessa steps" sequence, making dramatic use of things like strong diagonal lines to intensify the sense of conflict and collision. One of the most striking bits seems to show a sleeping stone lion waken and leap to its feet in alarm. Here, Eisenstein tells us, he used a montage to communicate a clear thesis: "even a stone lion arises in protest" at bloodshed on the Odessa steps.

The lion montage, an animation-style intersplicing of shots of three different stone lions, became the basis for an elaborate theory. Every bit as self-conscious an artist as Griffith, Eisenstein churned out thoughtful essays in tandem with his cinematic efforts. His vision of cinema was extremely utilitarian in the sense that everything in it pointed towards an ultimate goal: a perfect socialist state in which art itself would be obsolete. The director, whose hero was Leonardo da Vinci, saw himself as a

scientist as well as an artist, a kind of engineer of mass consciousness. He was delighted with the idea of using cinema to convey specific propositions and wrote of "a cinema of concepts" and the "construction of a language proper to the cinema, its syntax, alphabet and form [evolving] from the system of technical phenomena." Montage used image-association to lead the viewer to specific conclusions. Eisenstein pointed to a scene from *Intolerance* in which Griffith uses a simple juxtaposition to establish character. A man is introduced after we see a wall of his chamber completely covered with pictures of naked women. It is a clear equation: naked women + man = lecher. "If you want to arouse sympathy for the hero, you surround him with kittens, which unfailingly enjoy universal sympathy," wrote Eisenstein, adding that "not one of our films has failed to show White officers juxtaposed to disgusting drinking bouts, etc."

He wanted to go beyond mere stereotypes, however, and on into uncharted territory. Sounding alarmingly Pavlovian, he expressed interest in using conditioned reflexes to lead people to *new* conclusions. Stage Two of his film language appears in *October* (1928), which dramatizes the events of the Russian Revolution. It features an "atheism" montage, a sequence rapidly juxtaposing shots of Christian icons with sacred idols from around the globe – Inuit, Buddhist, Hindu, African, and so on. This thesis (God = a block of wood) relies upon an assumption of contempt for all the associated imagery drawn from foreign religions. People were cued to laugh upon seeing a crucifix in quick association with, say, a carved Yoruba god. (Incidentally, this sequence allowed the director to explore his lifelong fascination with religious imagery while seeming to denounce it – rather like Griffith with his war imagery.)

Eisenstein likened the film language of montage to Chinese characters. Written Chinese is based upon images rather than sounds, which are the basis for Indo-European scripts like the Roman or Cyrillic alphabets; therefore no demarcation exists between pictures and language. Further, a single character may join two apparently unrelated "pictographs" to convey a third concept — the two images "add up" to a third. Eisenstein terms this technique, which was apparently developed by a calligrapher called Ts'ang Chieh in 2650 B.C., "copulative." The third image becomes "the happy event." Eisenstein gives the following examples from Chinese characters:

> water + eye = to weep
> ear + door = to listen
> dog + mouth = to bark
> mouth + baby = to scream
> mouth + bird = to sing
> knife + heart = sorrow

"But — this is montage!" he exults. Both systems juxtapose concrete images (water, a mouth, a bird) to represent actions or abstract ideas (to listen, sorrow). "Each taken separately corresponds to a *concept*," he explains. "The combination of two representable objects achieves the representation of something that cannot be graphically represented." He would do the same thing with cinematic images. Instead of showing a weeping child to convey the idea of sorrow, Eisenstein could use montage to achieve the same effect unsentimentally (knife + heart). While Griffith envisioned the Universal Language mainly in terms of universal emotions, Eisenstein wanted a more cerebral and more precise effect.

Montage would provoke ideas rather than emotions, creating an "intellectual cinema" via the most "laconic" means. Eisenstein again strikes a sinister note when he speaks of "developing and directing the entire *thought process*," adding that "this form is best suited to express ideologically critical theses." Also inherent in his notion of montage as violence — tension, conflict, and collision. Montage becomes "an idea that derives from the collision between two shots that are independent," for example. In *October*, then, form and content become one.

Another peculiarly Communist innovation of Eisenstein's was "typage," a method of casting which had its roots in the fixed types of the Italian *commedia dell'arte* tradition and in the pseudoscience of physiognomy. Rather than employing actors (something he deemed "artificial"), Eisenstein preferred to cast ordinary people using an elaborate and time-consuming method. If, for example, he wanted to cast a street cleaner, he would tour the country photographing a great number of actual street cleaners. Spreading all the photographs before him he would perform a kind of calculation, adding up noses and cheekbones and eyes and beards to arrive at some kind of ultimate sign of "street cleanerness" in a universal language of faces. He would then cast the person, not necessarily a street cleaner, whose features most closely conformed to his formula. Eisenstein cast a bearded gardener as the quintessentially priestly priest of *Battleship Potemkin*. (For some reason he also dressed up as the priest on the set of *Potemkin*.)

Eisenstein had the Soviet seal of approval, at least for the time being. He was almost unrivalled among Russian filmmakers and was winning accolades in the West, where he got an ecstatic reception from leftists and grudging respect from those

who rejected his politics but admired his technique. Mary Pickford and Douglas Fairbanks saw *Potemkin* when they visited Moscow in 1926. "How long does it take you to pack your bags?" Fairbanks asked Eisenstein. Returning to America with a print of the film, they promoted it and its auteur, whom they said had mastered "the science of motion."

When he invited Eisenstein to Hollywood, Fairbanks had hinted at work with United Artists. This invitation stuck in the Russian's mind. He longed to see the "film kingdom," to meet Charlie Chaplin and visit the Disney studios (his love of Disney's animation belied his austere disdain for mere entertainment; he maintained that it was the best thing to come out of Hollywood). Another lure to North America presented itself in the chubby form of the Mexican painter Diego Rivera, who visited Moscow in 1928 and regaled the director with tales of his intense and iconic homeland. Crucially for Eisenstein's subsequent artistic and spiritual development, Rivera planted a seed. The enchanted landscapes of the Americas attracted Eisenstein powerfully.

A travel opportunity arose the following year. Because the Russian authorities were eager to learn about the new sound technology they decided to send Eisenstein and his team to the West as cultural ambassadors. The talkies had dashed Griffith's hopes, but in a funny way they opened Eisenstein's horizons. He greeted the prospect of sound films calmly, reasoning that sound would become a new element of montage. In a manifesto, the "Statement on Sound," co-signed by fellow filmmakers Vsevolod Podovkin and Grigori Alexandrov, Eisenstein champions the "contrapuntal" use of sound. Sound *at odds* with images would form a pleasingly jarring new juxtaposition.

He felt that Disney's Mickey Mouse films made good use of contrapuntal sound, introducing sounds arbitrarily rather than attempting to match them with images. The mismatched elements would collide to produce a third effect.

On the pretext of learning about sound films, then, the Eisenstein team departed for America. Eisenstein was dismayed by the inhuman scale of New York, with its canyons of skyscrapers and grid of streets. He kept getting lost, claiming that everything looked the same to him. He was also dismayed there by a burst of negative publicity. An especially active anti-Communist, Major Frank Pease, had organized a rally to denounce the director as a "red dog and sadist" and had called for his immediate deportation. Eisenstein was not deported, but his American connections began to fray. The United Artists deal he had hoped for did not materialize, but Paramount came through with a three-month contract. Before leaving for California, Eisenstein went to the lobby of the Astor Hotel to meet with the director he termed "the Great Old Man of all of us" – D.W. Griffith. As Eisenstein biographer Ronald Bergan puts it, "the 'old man' was only fifty-five but drink, poor health, and the 'nightmare of mind and nerves' – his description of the recent making of his penultimate film and first talkie, *Abraham Lincoln* – had aged him far beyond his years." Something similar was in store for his disciple.

The Russians made their way west. Trouble was in the air when their train finally reached California. Public opinion was stirred up against these Communist visitors, and the Hays Office (the morals watchdog that had been brought into Hollywood following a rash of scandals) warned Paramount it had better keep a close eye on the Russians. Overall, Eisenstein had

a singularly odd time in movieland. He loved the natural environment there and characterized "the golden hills of Hollywood" as possessing "all the earth's charms and blessings." He stayed at the fabled Hollywood Hotel, then moved to a comfortable Spanish-style villa in Coldwater Canyon. The villa came with a swimming pool, a car, and a cook. Eisenstein made the rounds of parties and visited various studios. He was photographed shaking the paw of canine star Rin Tin Tin. He spent some happy hours with Walt Disney and was photographed hand in glove with Mickey Mouse, two years old in 1930. Human beings seemed less eager to be photographed with him, however, for there was much anti-Communist feeling in Hollywood. The Russian émigré enclave hated him, naturally. Doug and Mary thought it wise to steer clear of him, and no invitation to Pickfair was forthcoming.

Eisenstein tried and failed to complete several projects at Paramount. He worked on a scenario for an unfinished Griffith project: a screen adaptation of Theodore Dreiser's *An American Tragedy*. He had met Dreiser in Moscow and liked his novel. The project initially interested him very much, not least for its connection to Griffith. However, his methods annoyed the studio executives. He rejected the star system in favour of typage, and he wanted to work with his Russian team — especially his cameraman Eduard Tisse and his assistant Grigori Alexandrov — as he always did before, whereas Paramount wanted him to work with its people. The project collapsed. A second scenario for a film called *Sutter's Gold* was ultimately rejected. Based on the true story of a Swiss immigrant who founded a settlement named New Helvetia in 1839 and discovered gold there, the scenario ends on a dark note: "The flourishing paradise of Cap-

tain Sutter's Californian groves and pastures were trampled underfoot and crushed by filthy crowds lusting for gold. Sutter was ruined." The project was shelved because the studio was wary of its moral (Gold annihilates man and nature). Another director would probably have been allowed to make it (one thinks of Erich von Stroheim's *Greed*), but Hollywood distrusted Eisenstein because of his politics. Paramount offered him a ticket back to Moscow in October 1930.

Hollywood had rejected Eisenstein. However, bohemian Charlie Chaplin was more friendly than his partners at United Artists. In fact the two were lost in admiration of each other. "Of course," wrote Eisenstein later, "Chaplin is the most interesting person in Hollywood." The Russians spent a lot of time at Chaplin's house, playing tennis, swimming in their host's bowler hat-shaped pool, and loafing in the sun. They sailed with him on his yacht, once taking a three-day trip to Catalina Island, where they found themselves "surrounded by sea lions, flying fish and underwater gardens, which you could look at through the glass hull of special steamboats." Chaplin entertained his guests by acting out the gags from his latest film, *City Lights*, and even showed them the secret rough cut. He loved Eisenstein, but he could not or would not procure the director a deal at United Artists when things went wrong at Paramount. He did make a pivotally important suggestion, however. Eisenstein consulted Chaplin, saying he wanted to make an independent movie about the looking-glass world south of the border. Mexico inflamed his imagination as no other place had. It was primitive and spiritual and revolutionary all at once. In addition, Mexico has long stood as an alternative, and therefore a reproach, to all things American, and this attracted Eisen-

stein. He would thumb his nose at Hollywood and make the movie he wanted. He conjured up a film that would constitute the ultimate homage to Mexico — a place which he had yet to visit. Chaplin suggested contacting the well-known socialist writer Upton Sinclair for help raising the necessary funds. Eisenstein did so. Flattered and excited by an appeal from the famous Russian director, and relishing the opportunity to rebuke the Hollywood studio system he despised, Sinclair agreed. He gathered the money from his wife, her family, and various of their friends and acquaintances (thereby putting himself on the line in the most personal fashion). And so began the disastrous story of *Que Viva Mexico*.

Eisenstein and Upton Sinclair were incredibly poorly matched. The two had leftist politics and teetotalling in common, but seldom did they fail to rub each other the wrong way. The director was thirty-two when they met, twenty years younger than the writer. Sinclair had none of Eisenstein's impulsiveness and clownish sense of fun. In fact he was dour. Born into an impoverished and rather drunken family of genteel Southerners, he had developed in response a highly puritan sensibility. The tenor of his idealistic schemes tended to reflect this. He co-founded a spartan commune, the Helicon Home Colony in New Jersey, and was brokenhearted when it burned to the ground in 1907. He moved to Hollywood in 1915, apparently drawn by the pleasant environment, and soon began to hope that the movie industry could be reformed in a more co-operative mold. In 1934, in the midst of the Great Depression, he ran for governor of California on an anti-poverty platform (see "The King of California" for more on that campaign), all the while producing many novels — *The Jungle*,

a 1906 account of an immigrant worker's grim life in Chicago, was widely read and discussed — and pieces of probing investigative journalism. Eisenstein biographer Marie Seton tells us that Sinclair's "feeling for art was subordinated to his need to pamphleteer on political and social questions through the medium of novels." Whereas Eisenstein was in spite of himself and his rhetoric a true aesthete, having, as Seton puts it, "fallen in love with his art designed to destroy art," Sinclair saw art primarily as a teaching tool. Finally, and fatally, he knew next to nothing about the practicalities of moviemaking.

The Russian crew went to Mexico, promising to complete the project in three or four months. When three months had elapsed they had scarcely finished their research, much less written a scenario. They experienced a number of setbacks. In Mexico City Eisenstein was summoned to the police station. Their American adversary, Major Frank Pease, had written to advise the Mexican authorities that this political undesirable should be ejected from their country. The Russians were placed under house arrest. When protest cables arrived from Chaplin, Albert Einstein, and George Bernard Shaw, and when U.S. senators Borah and LaFollete intervened personally, the authorities relented. The Russians could roam free. However, every foot of film he sent to the States in the months to come was scrutinized by the Mexicans for politically inflammatory material and was sometimes censored.

Another factor slowing things down was that Eisenstein had only the vaguest of scenarios in mind. He did not know exactly where (or exactly what) he wanted to shoot; he only knew that he wanted to capture Mexico's essence on celluloid. He eventually sent Sinclair a rough outline for *Que Viva Mexico*. It would

have an eight-part structure, with a prologue, six "novellas," and an epilogue. The structure of the movie would be "a necklace, like the bright, striped colouring of the serape ... held together by a set of linking ideas." He wandered around at random looking for the right location, with everyone else trailing along behind. Sinclair's philistine and xenophobic brother-in-law, who had come along as business manager, sent home a steady stream of letters complaining of the food, the weather, the customs of Mexico, and the obscure and impractical ways of the Russians. (Eisenstein seems to have enjoyed tormenting him, and even dressed up as a Mexican bandit to scare him on one occasion.) A violent earthquake in Oaxaca was the least of their worries.

The wandering ceased when Eisenstein discovered the Tetlapayac hacienda. "The moment I saw it," he later remarked, "I knew it was the place I had been looking for all my life." Eisenstein's spiritual home was an old maguey cactus plantation in the state of Hidalgo. Workers would literally suck out the juice from the maguey cactus and leave it to ferment into *pulque* — strong milky white spirits. Originally built by the Spanish in the colonial period, Tetlapayac was a coral-pink fortress, with two rosy towers rising above the long cactus spears that surrounded it. It had a marble staircase, courtyards, and a charmingly decorated chapel where Eisenstein spent long hours contemplating the images. The hacienda owner, Don Julio Saldivar, had managed to retain his rights to it during the upheavals of the Mexican Revolution by pledging to make it into a co-operative. Eisenstein was enchanted, feeling he had wandered into an ideal community which was also a film set. He could want for nothing: there was natural beauty, lovely architecture, and all

Eisenstein direction a scene from Que Viva Mexico.

sorts of agreeable candidates for typage in the form of the Indian peons, dark and fine-boned people whose rich religious sensibility fascinated him. A Mexican friend was surprised to learn that Eisenstein was studying mysticism, especially the works of St. Teresa of Avila. That he became increasingly pre-occupied with the ritual aspects of Christianity is evident from the film he shot in Mexico and from his drawings; it also comes through strongly in a later film, *Ivan the Terrible*. Tetlapayac allowed Eisenstein to reconcile socialist idealism with his more hidden mystical side. Fortunately for him, Saldivar and the plantation workers reciprocated his interest; they took to him and to the idea of *Que Viva Mexico*. The film crew settled in and went to work.

Mexico gave Eisenstein his theme, the universal theme of the oneness of life and death. Death in Mexico is eminently viva-cious. The paradox of a joyful death has always been central to Catholic Christianity. In Mexico the feast of All Souls Day (November 2), often called the Day of the Dead, is celebrated with special intensity. This day has the skeletons, the mockery, and the trickery of Hallowe'en, but little of the fear. On Novem-ber 2 the dead come back playfully, and playfully they resume their usual activities for one day. Little clay figurines sold on that day show skeletons in a variety of mundane poses: there are skeleton street sweepers, skeleton mariachi bands, skeleton teachers, skeleton hookers. There are groups of grinning skull-faced figures at the park. Kids eat candy skulls and dance in processions of revelers in huge papier-mâché skull-masks. Mexico mocks death on Death Day and mocks everything else as well. The world turns briefly upside down. It is a day for

satire of all stripes, for traditionally the censorship laws are lifted on this day. There was much jesting and pamphleteering at the expense of Mexican officialdom in that era.

Eisenstein was thrilled. He loved the multiple levels of meaning suggested by Death Day, the way it could be seen to defy earthly authority as well as the Reaper. The team shot as much of the festival as possible. He wanted to bring out the varying conceptions of Time at play in Mexican culture: there was circular, seasonal time, rhythmic and regular; there was apocalyptic time, with the skeletons foreshadowing the resurrection of bodies; there was Marxist time, which pointed ahead to an imminent proletarian triumph. Who needed sets and stars and contrived crowd scenes when you had Mexico? Who needed writers when the stories were being enacted before your eyes? Eisenstein felt he had only to shoot the stories and weave them together, imagining a multi-tiered narrative like that of *Intolerance*. His film would capture Mexico's Aztec past, the Conquest, the revolutionary period, and future prospects in a huge epic sweep. The work was intuitive, open-ended. And it took forever to accomplish.

The Russians were living on Mexican time. In Russia, the authorities were angry that Eisenstein and his team had outstayed their travel permit, which had a twelve-month maximum. Rumours began to waft through Moscow: Eisenstein was not coming back. In Hollywood, Upton Sinclair was beginning to chafe. Miles and miles of unedited film spooled into California, bringing with it more and more requests for money. Sinclair loved most of what he saw and became convinced it would be a masterpiece — but he was dismayed, watching the rushes

in Hollywood, to see perfectionistic take after perfectionistic take of the same subject appear on screen. "Is the man mad?" he would mutter. He could not understand Eisenstein's endless aesthetic tinkering. It seemed to him they had much more than enough to make the great and politically serious film he wanted. He wanted *Que Viva Mexico* completed, for he could not afford to keep paying indefinitely. Bad weather, illness, and government red tape had slowed things down initially, delaying the start of shooting; now Eisenstein wouldn't *stop*. Sinclair felt he was being held hostage. Broke and fielding complaints from all his fellow investors, he began to panic. He even wrote to Stalin in an effort to get the director out of Mexico. He must have felt alarm when on November 21, 1931, he received this cable in return:

EISENSTEIN LOOSE [sic] HIS COMRADES CONFIDENCE IN SOVIET UNION STOP HE IS THOUGHT TO BE DESERTER WHO BROKE OFF WITH HIS OWN COUNTRY STOP AM AFRAID THE PEOPLE HERE WOULD HAVE NO INTEREST IN HIM STOP AM VERY SORRY BUT ALL ASSERT IT IS THE FACT STOP MY REGARDS STOP STALIN

When Eisenstein sent for his close female friend and house-keeper, Pera Attasheva, to join him from Moscow, permission was denied by Stalin. Eisenstein was shocked. The implication was clear that he was no longer considered trustworthy.

Many months and thirty-five miles of celluloid later, Sinclair finally decided to try to wrestle artistic control away from Eisenstein. First he stopped sending money. Then he decided to take all the film in his possession (virtually everything that

had been shot) and have it edited in the States. Perhaps he did not understand that Eisenstein did all his own editing. For the pioneer of montage, a technique in which the editing is as important as the shots themselves, this was in any case a declaration of total war. A film which was not edited by Eisenstein would simply not be an Eisenstein film. Furious, he impulsively wrecked any lingering goodwill between himself and Sinclair by sending the prim older man a trunk full of extremely lewd pornographic drawings. When the trunk was opened by a customs agent, the humiliated Sinclair had a lot of explaining to do. He never forgave Eisenstein for this ugly practical joke.

The contracted three or four months had spun out into fourteen. Eisenstein wanted to stay at Tetlapayac forever and promised to return, but he had to go and rescue *Que Viva Mexico*. In this he failed — more or less. Because of the legal battles between the two camps, the movie was never properly completed. Eisenstein never got his hands on the Mexican footage. He went back to Russia under a cloud. His disappointments in America had worn him down, changed him — friends said he had lost his happy spark. He had aged dramatically in the few short years he had been abroad. He returned to find Russia in a particularly dark mood under Stalin. (Eisenstein's two-part sound film *Ivan the Terrible* (1944) was in part an allegory of Stalin's murderous tyranny.)

Que Viva Mexico died and was delivered into a fitful afterlife. A couple of short films were cobbled together from it, and much of the footage was sold off for a pittance and cut up for use in Hollywood westerns. For years to come, anomalous bits and scraps flickered brightly through otherwise drab land-

scapes. Here and there the observant viewer was treated to a still composition of curved Aztec profiles, an icon and its shadow, a teeming crowd, a towering cactus, a boy who removes his skull-mask to reveal a radiant smile. *Que Viva Mexico* haunted Hollywood for a long while. But it was an ignoble fate for the film which was to have trumped Tinseltown once and for all.

The King of California

*A large rose-tree stood near the entrance of the garden: the
roses growing on it were white, but there were three gardeners
at it, busily painting them red ... "Would you tell me," said
Alice, a little timidly, "why you are painting those roses?"*

LEWIS CARROLL, *ALICE'S ADVENTURES IN WONDERLAND*

Upton Sinclair's next assault on Hollywood truly rattled its
ramparts. The year was 1934, and America was well into the
Great Depression; millions were on the bread line and even
golden California was feeling the pinch. Migrants fleeing the
Dustbowl states — places like Kansas, Texas, and Oklahoma —
were pouring in, and jobs were scarce already. Labour unrest
was growing, and unions firmly took root in the movie industry.
The studio bigwigs were nervous. Hollywood was vulnerable.
Would it be seen by the public at large as a source of comfort, of
pleasant escape in hard times, or would it instead, in all its glit-
ter and glamour, appear as a slap in the face of the poor? Upton
Sinclair promoted the latter view: Hollywood's ostentatious
wealth insulted struggling Americans. The popular writer
became a politician, developing the EPIC (End Poverty in Cali-
fornia) platform from the garden of his modest Hollywood
home. He had little money for a campaign, he admitted, but

had invested in a certain movie shot in Mexico which might eventually "interest the public" and pay off, allowing him to devote all his time to EPIC.

Sinclair put his talents as a fiction writer to use. In a remarkable pamphlet-novella entitled "I, Governor of California, and How I Ended Poverty: a True Story of the Future," Sinclair envisions as a *fait accompli* his election and the implementation and unmitigated success of a plan to abolish capitalism in California. Step one in the creation of this good place (*eutopia*) would involve the establishment of farming colonies, where the unemployed would go to work raising their own food; the government would raise taxes radically and buy back the means of production from businesses taxed out of existence. "I, Governor" sold very briskly — 150,000 copies in the first four months, which by Sinclair's reckoning made it the fastest-selling book in state history. Sinclair turned Democrat and then won the party's nomination for governor. Mild-mannered, bespectacled, teetotalling Upton Sinclair now posed a serious threat to the movie business (and to big business generally). And the money-men of Hollywood fought back.

No one fought harder than William Randolph Hearst. For Hearst, who by that time had parlayed inherited wealth into an immense media empire, merging his Cosmopolitan Pictures with MGM, it was a matter of duelling utopias. He understood Hollywood — the place, the product, the people, the satellites, the ideas — to form a virtual utopia (an *outopia*) which all America inhabited. At his extravagant coastal California palace, San Simeon, which contained the world's largest private art collection — paintings, sculpture, tapestries, porcelain, silver,

and furniture; whole rooms, whole churches imported stone-by-stone from Europe — he entertained half of Hollywood each weekend. There, with his movie-star mistress, blond Marion Davies, he showed off his riches on a scale rivalling Louis XIV at Versailles. Publicity brought it all to the people.

To a man of Sinclair's sensibilities, Hearst was an obscenity plain and simple. In the writer's imaginary Californian future there would be no place for such gargantuan figures. "The existence of luxury in the presence of poverty and destitution is contrary to good morals and sound public policy," he wrote. Ostentation like Hearst's was an affront to hungry people, Sinclair believed. He promised that in an EPIC administration "there would be no display at the ceremonies, no inaugural ball ... no evening dress." His employees would receive orders to "wear simple clothing and avoid display." In an otherwise abstractly worded document, Sinclair pointedly introduces the Hearst name. "When the Hearst papers told [then-Governor James Rolph] to kill the income tax, which is a tax on wealth, and to approve the sales tax, which is a tax on poverty, he did it." Sinclair envisioned a California in which "capitalist newspapers" would simply wither away from neglect. And the capitalists would fold up their tents and wander off.

It was unpleasant for Hearst, who liked to present himself as the people's champion, to find this killjoy casting him as their enemy. Hearst was a kind of populist king. And Americans have long responded to the display of pomp and riches like crowds at a display of royal pageantry. As a native Californian, Hearst had a claim to rule that newcomer Upton Sinclair distinctly lacked. He was born in San Francisco in 1863. His father, rough-edged

George Hearst, had bought a Californian gold mine which turned out to be empty of gold but crammed with silver. George Hearst later became a U.S. senator, but was always happiest at some distant campfire under the stars. He left the care of his son to his wife Phoebe, a cultivated woman who was happiest touring the great museums of France, England, Germany, Italy, and Spain. Their son loved the museums — indeed, at ten he bribed a Viennese guard to let him in to see a collection off-limits to youngsters. He adored and coveted the contents of the museums, but never forgot the pleasures of tent living *en famille* on the Hearst property at San Simeon, then a modest ranch. (He finally succeeded in fusing the two worlds when he built his fantasy castle on Camp Hill, where their tents once stood. Now he could spend the rest of his life "camping" under Californian skies, but surrounded by the treasures of Europe.)

Young Willie Hearst was shy and impulsive by turns — just like old Willie Hearst. He loved entertainments and practical jokes; he was spoiled silly by his mother. As his father remarked: "There's one thing sure about my boy Bill ... I notice that when he wants cake, he wants cake; and he wants it now." He was blond and blue-eyed and grew very tall, but his squeaky little voice never deepened. When crossed he would sometimes fly into a rage and break the contents of a room, shrieking in his tiny voice. As a young man he went to Harvard, which he hated. He didn't study much, but kept an alligator in his rooms which he plied with liquor and dubbed Champagne Charlie (the creature soon died of liver failure). Willie was active in Hasty Pudding, the theatre group, and in staging various spectacles and pranks. He was soon thrown out of Harvard, in part for playing pranks on the wrong people — professors. He

Hearst's personal palace at San Simeon contains a massive collection of art and antiquities. PHOTO: GETTY IMAGES.

subsequently dropped out of Yale. Phoebe Hearst was crazed with worry. Coming into his fortune, Hearst moved to New York City and decided to enter the newspaper business, although he could have forgone work and led a life of pure pleasure. But he

was too full of energy for that. Actually, his whims and wants were too urgent, too all-encompassing, for a life of leisure. Hearst needed to impose his colossal will on the world.

Hearst wanted possessions — estates and antique furniture and precious *objets d'art* — as forcefully as anyone has ever wanted such things. He wanted sway over individual lives (family, friends, employees); he sharply desired the love of the public. And he wanted the presidency. Essentially, Hearst craved worldly dominion, and he believed himself to be an eminently fit ruler of the American people. He sought this power through newspapers. Soon he had founded or acquired a paper in every big city in the U.S.A., and from there he went into magazines and beyond. Refusing to delegate power to underlings, "The Chief" made all the executive decisions for all his publications ("The Organization"). Through the Organization he spread his opinions and promoted himself and others for public office.

It was through this ideal of populist kingship that Hearst was able to reconcile his lordly style with progressivist politics. In spite of his wealthy family, Hearst saw himself as a renegade in league with average Americans against the establishment. Some of the Hearst papers set the tone for today's tabloids — relentlessly "popular." Lurid and scandal-mongering — at least by the sober standards of the day — flag-waving, provocative, and entertaining, the papers often pitted class against class. They led a series of crusades, notably against the powerful Trusts. They were constantly under attack by graver figures in the news business. Some Hearst reporters, none too fussy about facts, tended to stir up news rather than report it. The Chief was proud of his role in *causing* the Spanish-American War of 1898. Biographer W.A. Swanberg observed that Hearst was "essentially a show-

man and a propagandist, not a newsman." Through his newspapers he promoted a series of candidates for political office — mostly Democrats, mostly without success — and trumpeted a brand of "America first" policies that often dovetailed with his own interests. But Hearst never doubted that his interests were identical to America's.

The Spanish-American War notwithstanding, Hearst usually discouraged America from going to battle. He used the language of pacifism when he came out against the U.S.A. joining the World Wars, but his instincts were more isolationist than anything: America first. Hearst hated the idea of his country sacrificing itself for Europe, particularly the old enemy, England. He mistrusted all the old rival colonial nations — especially England, France, and Spain — which had jockeyed for power in the Americas. This left Germany, which Hearst had always rather liked. He liked its people, its beer, its landscapes and castles (especially that of Mad King Ludwig). Mad King Hearst owned a series of dachshunds, each named Helena, and this appeared to emblematize his goodwill towards Germany. This attitude came back to haunt him as America got closer to war. When war came, dachshunds were kicked in the streets. Hearst was burned in effigy along with his newspapers.

Hearst seemed to believe that America should let Europe fight itself into oblivion, while he himself salvaged its artworks from the rubble. The Europeans were in any case no longer fit guardians of the patrimony of the West. The New World could skim off the best of the Old without remorse. What else did Europe have to offer America beyond great art and architecture? Hearst was accumulating a goodly part of Europe's treasure as part of a "creative rescue" (in biographer David Nasaw's

phrase) and stashing it in the vast warehouses of the Bronx. In his dreams, a castle shimmered on a hill overlooking the shores of the Pacific. His estate would be the most beautiful place in the world, he promised himself, and it would boggle the minds of everyone who saw it — of everyone who *heard* of it. Hearst was extraordinarily influential in America, overseeing a massive newspaper empire and throwing his weight around in politics. But his power had limits and often faltered. On his dream estate, life could be ordered exactly as he saw fit.

Hearst liked to spend the summers camping at San Simeon. In a tent village on the hill by the ocean, he and his entourage whiled away the sunny days swimming, picnicking, and horse-back-riding across the huge acreage. Hearst, who was fascinated by motion pictures and had decided to start a movie studio of his own, brought along a movie camera and shot do-it-yourself dramas. Everyone, including the ranch hands, was pressed into service. A typical creation was "The Romance of the Rancho," featuring his wife, Millicent, a former chorus girl, as a damsel captured by bandits. Hearst was the hero, rushing onto the scene with a six-shooter. He knew how to show his companions a good time.

The company was lolling in the tents one evening on Camp Hill when the host appeared with a bulky object under his arm. His face was tense with meaning. "I have something to show you all," he said. He held up a miniature castle tricked out in plaster. "This is the house I will build right at this very spot." The scale model was the work of Julia Morgan, a young San Francisco architect who had already designed a Bavarian-style spired castle for Phoebe Hearst. Morgan's design for Phoebe's son was more strictly Californian in style. Featuring twin tow-

ers, it was roughly modelled on a Spanish cathedral Hearst had seen and admired. Inevitably, a Spanish church evoked California's "Mission" heritage. Hearst called his castle "neo-Mediterranean" in style.

He had collected enough antiquities to furnish several castles before work ever began at San Simeon. In so doing, he had gained a strange reputation among dealers worldwide — unlike most collectors, Hearst didn't specialize: he wanted everything, and he wanted it now. Dealers were often roused from sleep to appease a sudden craving. He didn't bother to feign indifference to objects he desired, and cheerfully compared himself to a dipsomaniac. To beat out another buyer, Hearst once paid $375,000 for a Van Dyck portrait of Queen Henrietta Maria — an outlandish sum in 1918. Throughout the Teens and Twenties he spent an average of $1 million a year on art and antiquities. Combing the auction catalogues, he would order tons of lavish stuff sight unseen. Actually he *never* laid eyes on most of the objects he bought, though he displayed an uncanny awareness of what lay in his labyrinthine warehouses. His three-storey New York residence grew so thickly peopled with statues and suits of armor that there was scarcely room for Hearst's wife and five sons. Guests picked their way around paintings lying in stacks and leaning against massive armoires. A penthouse was added. Now theirs was the biggest apartment in the world.

But a loving wife and five sons, an immense apartment, a newspaper empire, his new Cosmopolitan Pictures movie company, and countless possessions were not enough for Hearst. He wanted a fresh young princess, a girl who would be worthy of his air-castle. He found her. Several years before San Simeon saw bricks and mortar, it had a chatelaine — Marion

Marion Davies, William Randolph Hearst's beloved mistress, circa *1921.*

Davies. It was 1917 and the millionaire was pushing sixty when he plucked his showgirl from amid the dreamy sets of the Ziegfeld Follies. Hearst attended the show night after night – every night for eight weeks running, by some accounts. He

soon made her his mistress. Yellow-haired Marion, who came from a modest Catholic home, was funny, generous, and cheerful. She was perfectly all-American, combining glamour with youth and an easy democratic manner. The *coup de grâce* was an adorable stutter which made her seem a bit vulnerable. Hearst wanted to protect her forever.

Many of the Hearstian preoccupations came together in the figure of Marion Davies: youth, beauty, America, exalted womanhood, fantasy, and fun — entertainment itself. Hearst's efforts to make a huge movie star of Marion Davies are well-known. An impresario at heart, he had embraced the movies early on, producing cliffhanger serials like *The Perils of Pauline*, starring Pearl White. Now Hearst wanted his fair lady to outshine Mary Pickford. Tutored, trained, and retooled, Miss Davies rapidly became the top-billed player of Cosmopolitan Pictures. The Hearst papers sang her praises. Hearst hired Joseph Urban, the Viennese designer of the Ziegfeld Follies, to create sets elaborate and fanciful enough to set off the golden Miss Davies. The sets always won approval from critics, even if the leading lady didn't. He also hired Frances Marion, Mary Pickford's screenwriter, at $2,000 per week. The characters she wrote for Miss Davies were always ingenues, absolutely pure and lovely. *Cecilia of the Pink Roses* (1918) featured her as a demure maiden, and she played the exalted role of Mary Tudor in *When Knighthood Was in Flower* (1923), a movie which won the admiration of Edward VIII. Hearst hesitated to let her play a mother. (In this at least she did resemble fey little Mary Pickford, who played actual children well into her thirties.) And "W.R.," as she called him, hovered on-set as much as possible, anxiously overseeing every detail connected to his darling. This annoyed his

directors, but didn't seem to bother Miss Davies. She received his attentions tenderly. "The old b-b-b-b-bum," she would stutter smilingly, shaking her blond head in mock despair.

As Millicent was unwilling to divorce, Hearst could not remarry. But he was able to give Maid Marion her castle when Phoebe died in 1919. His mother's death left him grief-stricken. However, it gave him the cash necessary to bring his dream world into being. His frantic acquisitiveness also intensified. He sucked up Old World art and antiques at an ever more frantic pace. The foundations went in on Camp Hill. They were built to last – the whole design of the castle reflects, as David Nasaw has observed, Hearst's belief that California would be the seat of a new civilization which would outshine Europe. In California, Hearst reasoned, the most precious gems of Europe could find a new and better setting. (Sometimes the local people protested the loss of their heritage, as did the inhabitants of a Spanish village when the American millionaire bought, disassembled, and shipped off an entire monastery which had stood near the town for centuries.) California would take what was excellent in Europe, reconfigure it, and come up with something to top it. California would remake the whole world.

Atop Camp Hill, which its owner now renamed La Cuesta Encantada ("The Enchanted Hill"), an extraordinary edifice was taking shape. It was to consist of four parts. The twin-towered main house, known as La Casa Grande, would be flanked by three smaller guest-houses: La Casa del Mar ("House of the Sea"), La Casa del Sol ("House of the Sun"), and La Casa del Monte ("House of the Mountains"). The four houses were furnished with the contents of the two Bronx warehouses. Each smaller house had a garden with its own colour scheme. Two

immense tiled swimming pools were built, one inside and one out. Statuary postured all around the grounds. Meanwhile, paradisically lush trees and flowers were being coaxed out of the dry rolling landscape. Once the bulk of the building was complete, Hearst began acquiring animals to populate his Eden. Soon he had the world's largest private zoo. Some creatures were caged, like lions, tigers, and bears, foxes, wolves, and chimpanzees; others, like giraffes, water buffalo, kangaroos, ostriches, musk oxen, camels, gnus, zebras, moose, and yaks, roamed freely over the enchanted lands. At feeding time they materialized along the roadway in droves.

The Chief had authored a new realm, created a fairyland with laws reflecting his prodigious will. For one thing, in this paradise the beasts of the field and creeping things enjoyed a kind of dominion over men. They had right-of-way. The place was dotted with signs proclaiming it. Humans were forbidden to inconvenience the animals, who often lounged infuriatingly on the road, blocking all traffic. Gossip columnist Louella Parsons was once held up for hours by a sleeping moose, while Winston Churchill was delayed by a giraffe. Hearst himself put aside business to attend to a seal who blundered into La Casa Grande one afternoon.

W.R.'s heart bled when one of his creatures died. Servants had to leave out tidbits for even the mice lest they starved, and were forbidden to use mousetraps; rather, they were directed to catch the mice in wire baskets and release them outdoors. Even the death of a tree gave him pain, and he hated to spy dead flowers anywhere, so the servants were careful to conceal such things, going so far as to paint dead trees green. The gardeners even concealed themselves. Because the Chief did not like to

see pruning, cutting, weeding, and chopping, they did their work by night. A guest awoken by the unearthly shrieking of leopards in the night might gaze out a bedroom window and see torches burning in the gardens. Sometimes castle-dwellers would awake in the morning to find the grounds magically transformed. One Easter they were suddenly brilliant with thousands of pink-and-white lilies — a surprise for Mr. Hearst from the head gardener.

Hearst collected amusing, interesting, and beautiful people the same way he collected everything else. Once he and Miss Davies moved out West in 1924 (Hearst had sold Cosmopolitan Pictures to MGM), the couple hosted a house party virtually every weekend. Everything turned upon Marion Davies. The castle was built for her, and it was her sunny, casual, generous way with people that set the tone and made all the play possible. Without her, Hearst would have been just a shy, eccentric old man rattling around in his vast domain (as Orson Welles later imagined him in *Citizen Kane*). He was haunted by the fear that she would leave him; he hovered around her possessively. But she didn't leave him. By now she loved him as much as he loved her. "I started out as a g-g-g-gold digger," she confided to a female friend, "and ended up in love."

An invitation to San Simeon soon became the most coveted thing in Hollywood — more so even than a summons to Pickfair. Marion Davies finally eclipsed Mary Pickford — not as an actress, but as a hostess. Unlike Pickfair, San Simeon was never stiff and formal. It was a kingdom that somehow contrived to be democratic. Hearst habitually called it "The Ranch"; in print he once described his opulent 265,000-acre estate as "a little hideaway on a hilltop." Guests were encouraged to be

relaxed and spontaneous even as they were carefully guided from place to place and from activity to activity. A private train took them from Los Angeles to San Luis Obispo, from whence they were driven by limousine to the castle. They were told to come without servants. As soon as they passed into Hearst territory, Hearst rules applied. The animals wandered over the rolling acres. From afar the travellers could spot the twin towers, floodlit and often wreathed in fog, rising out of the hillside. They passed from the castle foyer with its featured statue of Pygmalion and Galatea into an ornate sitting room. There they were joined by their host, who emerged from an elevator fashioned from an antique confessional.

Rather a shy man at heart, Hearst liked companions who could put him at ease. He loathed stuffy manners, preferring jester types. His taste in guests contrasted sharply with Mary Pickford's, which ran to bluebloods and other toffs. Charlie Chaplin, a man who set Pickford's teeth on edge, was his favourite. Chaplin came to San Simeon practically every weekend (reportedly he had a terrible crush on Marion, which may have had something to do with his constant presence). An incredible parade of people rolled through the castle over the years. There were movie stars – Buster Keaton, Greta Garbo, Clark Gable, Theda Bara, Cary Grant, Claudette Colbert, David Niven, Louise Brooks, Douglas Fairbanks, little Shirley Temple; the list is endless. There were politicians like Churchill and grand authors like George Bernard Shaw. The aviator Charles Lindbergh visited with his wife. But the really notable thing about Hearst's guest list was that lots of unknowns were invited too, people from the lower levels of the Hollywood hierarchy, like office workers – ordinary people with a little charm or

looks or talent who suddenly found themselves elbow-to-elbow with the biggest celebrities in the world. Nothing like that ever happened at Pickfair. In fact, nothing like that ever happened at all in Hollywood society anymore – except at San Simeon.

Hearst had conjured up the atmosphere of Hollywood's very earliest days. Chaplin was among those who could remember those fleeting times, before the money began rolling in, when movies were being pioneered in California. Directors had doubled as electricians and editors as extras; there were no "stars" to speak of and the whole enterprise felt like a camping trip, which, of course, was exactly what Hearst had in mind when he created his castle. The famous dining room, with its long forty-person refectory table, lay upon the spot where W.R. had camped with his parents back in the 1870s. As a tribute to those days, he insisted on paper napkins. Lowly condiments – Heinz ketchup, mustard, and relish – had to be served in their original bottles. The labelled bottles sat among the candlesticks and gleaming silverware, reminders of picnics past. And there were lots of real picnics too. Periodically the whole company would ride out on horseback, packed mules alongside, and pitch tents on the land. They would sometimes spend three or four days out there, riding, sunbathing, and barbecuing under the stars. Back at La Casa Grande they danced, played tennis and croquet, swam in the pools, and watched Hollywood's very latest offerings in the private movie theatre. There were extravagant costume parties.

Hearst's was a childlike land of make-believe. It was as if he were the boy with the best fort in the neighbourhood, and everyone had come to play there. The guests frolicked like children, and like children their fun was carefully regulated.

Because their host frowned on excessive drinking — he usually toasted the company with a tall glass of water and worried about Marion Davies' intake — booze was scanty. People were limited to one cocktail before dinner. Communal life was very important. Guests were expected to participate in outdoor activities and to attend meals punctually. Anyone who skipped meals without a water-tight excuse was apt to find a note of dismissal pinned to his pillowcase: thanks for coming, but your room is needed for someone else now. Finally, bed-hopping was discouraged. Only married couples were supposed to share a room. (Some found this odd in view of the fact that their host and hostess were unmarried. But Hearst and Marion Davies said they meant no disrespect to marriage — they *wanted* to wed, but Millicent was staying firm. There would be no second Mrs. William Randolph Hearst.) In short, life at San Simeon, though lavish, was not the bacchanal that many imagined.

~

And imagine they did. Hearst was playing a tricky game, speaking out for correct conduct in movies and life while shacked up with his young mistress. Hollywood had begun to come under close and often unfriendly scrutiny in the early 1920s after a series of scandals implicating some of the biggest stars — the drug-related death of a young star, Wallace Reid; the unsolved murder of director William Desmond Taylor; and, most notoriously, the arrest of popular comedian Fatty Arbuckle for murder. Arbuckle was accused in the nasty death of a young actress, Virginia Rappe. He was acquitted, but the ugly impression lingered (actually the Hearst papers were particularly hard on him), and every day seemed to bring a new story about

drugged-up decadent movie stars. Meanwhile, as the Roaring
Twenties revved up, movies were becoming increasingly salty.
Many members of the country's public and civic bodies were
ready to boycott Tinseltown. Then came a crucial ruling from
the Supreme Court, which defined movies as primarily a profit-
making enterprise, an industry, and thus not fully covered by
First Amendment guarantees of freedom of speech. Many states
passed censorship laws, laws which could block certain movies
and cause financial damage to the studios. Hollywood decided
to practise self-regulation. Twelve representatives from the
major Hollywood companies got together and appointed Will
Hays, a former postmaster general, to monitor the film colony's
mores and movies. Working with the studio heads, Hays devel-
oped something called "the Formula": studios would send him
synopses of "questionable" books and plays they were consid-
ering for development, and he in turn would warn them about
any dangerous material he came across, anything he consid-
ered lewd, decadent, or depraved. He drew up his personal
Index of Prohibited Books. He also persuaded the studios to
add "morality clauses" to actors' contracts, so the actors had
compelling reasons to behave themselves. Installing Hays as
movie czar was one of the things the studios did to keep the
industry afloat. Another thing they did, as we have seen, was
oust silent films in favour of the talkies when audiences began
to thin out in the late 1920s.

In the 1930s, the threat to Hollywood came from another
quarter: socialists. From the perspective of Upton Sinclair and
the End Poverty in California camp, moral restraint at San
Simeon was meagre consolation when wealth on a colossal

Upton Sinclair's asceticism brought him into conflict with the extravagant Hearst. PHOTO: GETTY IMAGES

scale was being flaunted in the faces of those on the bread line. There were Hearst and all the other Tinseltown fat cats living it up while great chunks of the populace were starving. It made Sinclair sick. Writing in 1934 of the reasons which spurred him to enter the gubernatorial race, he mentioned with distaste "our richest newspaper publisher keeping his movie mistress in a private city of palaces and cathedrals, furnished with shiploads of junk imported from Europe ... telling it as a jest that he had spent six million dollars to make this lady's reputation, and using his newspapers to celebrate her change of hats." He was determined to get elected and turn California's eco-

nomic system upside down. He would create a "paradise" where "social ostentation, being no longer possible, [would be] no longer necessary."

One wonders why Sinclair, who experienced Hollywood as a scandal and an outrage, chose to move there after his New Jersey commune burned down. The answer must lie in California's utopian dimension. Sinclair, an idealistic man, saw a chance for a better life in that sunny state — not only for himself and his wife, but also for ordinary Californians who were suffering. The beautiful setting inspired hopes for a sweeter life for mankind. In "I, Governor of California" he writes of having come to the state so as to "see the new sunshine on the wet grass, and on the scarlet hibiscus flowers and the pink oleanders and the purple and golden lilies." He describes himself as a reluctant politician, forced to emerge from his "garden with a high wall around it" like a turtle from its shell. It was hard to enjoy writing tranquilly among the flowers, he tells us, "when you know that millions of your fellow citizens are suffering from hunger." Sinclair believed it was not enough for Californians to enjoy wealth vicariously, through movies and magazines. He wanted to change their circumstances materially.

The prophetic structure of Sinclair's pamphlet was perfectly suited to his utopian politics. "This is the first time a historian has set out to make his history true," he remarks. Sinclair confidently posits the near future for California. Citizens had only to vote him in to realize it: "so I have to make it my own story, and you have to decide whether you wish it to be yours." When the poor were organized into land colonies and put to work feeding and clothing themselves, big-business profits would plummet as their taxes skyrocketed, and big business would die

off. Using the tax money, government would take over those bankrupt businesses and gradually buy up the private land. California would retreat from the U.S. dollar and bring in its own money system based on scrip. Everything from farms to kitchens and cafeterias would be co-operative on the colonies, "run by the state under expert supervision"; there would be common rooms "for social purposes." Finally, culture would be removed from corporate hands when "every land colony become[s] a cultural centre, with a branch library, a motion picture theater, [and] a lecture hall where we can explain the principles of co-operation." Sinclair speaks of co-operative farms and the like, but presents the EPIC platform in terms that would sit well with average Americans. He styles himself as a Jeffersonian democrat and true Christian. He invokes God frequently. The statement "God created the natural wealth of the Earth for the use of all men, not a few" heads off a list entitled "The Twelve Principles of EPIC." He rounds off the list with an allusion to voting and the American way: "This change [i.e., EPIC's program] can be brought about by action of the majority of the people, and that is the American way." Sinclair was walking a political tightrope. On the one hand he had annoyed many of his old socialist companions when he joined the Democratic Party; on the other, many Democrats were alarmed that someone so left wing had won the nomination. Sinclair averred that the EPIC program came first, the Democratic Party second.

When someone in EPIC suggested they adopt "the little brown hen" as their official emblem because the hen industriously lays one egg a day, Sinclair demurred in favour of "the busy bee," saying, "I like the bee. She not only works hard but has the means to defend herself." Sinclair knew that EPIC

The EPIC Bee, the official emblem of Upton Sinclair's End Poverty in California program.

would need that means. He counselled voters to "bear in mind that there will be no limit to the money which will be poured out to defeat this plan."

He was dead right about that. No sooner did the writer win the Democratic nomination than a "Stop Sinclair" drive sprang up in Hollywood. Hearst, for one, had invested himself heart and soul in the movie world, and he was not about to let Sinclair spoil it by applying the EPIC economic formula of tax-

and-takeover. Describing the abstemious writer as "a perfectly well-meaning man but a wholly impractical theorist," he reproached Americans for "traipsing after every irresponsible adventurer with a penny whistle to play and a seductive song to sing." Hearst and Louis B. Mayer joined forces with other movie executives to block EPIC. They threatened to transplant the film colony to Florida if Sinclair got in. They levied a day's salary from all movie-industry employees for an anti-Sinclair fund. Finally, cynically playing on Californians' fears of the Dustbowl poor, several studios released fake newsreels depicting teeming mobs swarming into the state, all set to take over private property when Sinclair became governor. Hearst's *Los Angeles Herald-Express* ran a still from an old hobo movie on the front page; it purported to show a scary mob of bums come to usher in the EPIC era.

Republican Frank Merriam won the election by 220,000 votes.

Upton Sinclair retreated behind the walls of his garden to resume his writing career. "We are well rid of him," wrote Hearst to an associate. He had won this battle, but still had many more before him. As the Thirties wore on he faced challenges on a number of fronts. At San Simeon, construction on La Casa Grande continued: the house was never truly complete. This made it interesting for Hearst, who got bored when things were finished. His estate, with its infinity of objects from everywhere, its sea front and gardens and Noah's Ark of animals, was a world unto itself. Hearst is perhaps most notable as a fantasist — in bricks and mortar rather than words. His estate was an extension of Hollywood in more ways than one: movie-world social life extended there, and the public also made an

imaginative identification with the place. While there is no doubt that San Simeon's creator was a colossally selfish man, it bears emphasizing that the place was originally conceived as a museum that would one day be open to the public — as in fact it now is. This private extravaganza was designed with a public future in mind. It was an emblem of the emergent Californian civilization that would incorporate the best of the old in something new. In this respect, at least, Hearst shared something with the Theosophists like Katherine Tingley, who built Point Loma, and with the aesthetic idealists like D.W. Griffith, who believed that California could make an extraordinary contribution to the modern world. Hearst's was the unendingly optimistic view which saw California, the America of America, as a realm where everything would necessarily improve. For Hearst, California's destiny was indistinguishable from the sheer force of his own will.

Six

Shipwrecked on Prospero's Isle

Oh, come, my love, and join with me
The oldest infant industry.
Come, seek the bourne of palm and pearl
The lovely land of Boy-Meets-Girl.
Come grace this lotus-laden shore
This isle of Do-What's-Done-Before . . .

DOROTHY PARKER, "THE PASSIONATE SCREENWRITER TO HIS LOVE"

Upton Sinclair lost the race for governor in 1934, a fact which gave Hearst some satisfaction. But it wasn't long before another of his prominent critics, Aldous Huxley, was at work on *After Many a Summer Dies the Swan* (1939). This was the novel which would inspire *Citizen Kane*, the 1941 movie that so upset W.R. he tried to have it suppressed. Huxley was even more unlike Hearst than was Upton Sinclair, who at least shared the publisher's quintessentially American faith in Progress. Sinclair envisioned a socialist paradise, and, in a similar vein, Hearst was a great optimist. He always expected things to get bigger, better, and more beautiful. Both put considerable faith in the future. Aldous Huxley had a much darker view of human nature and human history than either of these men. His expectations were basically dystopian. He saw a divine spark in man,

but thought on balance that the spark was being snuffed out. The mass culture of modernity had amplified human greed and violence, he believed. And whereas Hearst was profoundly at home in the Golden State with its palm trees and swimming pools, Huxley's stretched form always seemed weird against the Californian backdrop. Extravagantly tall and gangly, cerebral and upper class, sickly pale, practically blind, this hothouse production was no native Californian son — far from it. He was too effete, too English, and altogether too melancholy for that sun-drenched and garish scene. Actually, Aldous Huxley was in some ways a stock Californian character: the verging-on-insufferably superior Englishman who regards the place with a rich mixture of disapproval and longing.

The author of *Brave New World* made Los Angeles his home for some twenty-six years, though Huxley saw himself as in Hollywood but not of it. He worked there as a screenwriter, but always spoke of Hollywood as something apart, something crass and debased. The perspective of this writer, who drifted like a sudden black cloud across Hollywood's brighter skies, may be seen as an instance of what Mike Davis terms "L.A. *noir*." This is the dark and troubled, even apocalyptic, vision of Los Angeles which came to offset the sunshine-paradise image so familiar to us all. That sunny image was now old enough to invite a counter-tradition. Back in 1910, as we saw in "White Magic," "Hollywood" was just a name, designating little more than a pleasant spot for orange farming or retirement. By the time of Huxley's first brief visit in 1925, however, "Hollywood" was loaded with glamour — with big outfits getting rich and richer and occasionally going broke, with the dashed hopes of so many players, with glitter and grime of years. Hollywood now

entailed a sense of "lateness," the feeling that the world is old, its potential all but extinguished. In the 1930s, silent film had become a flimsy, empty ghost town; the dream of cinema as a redemptive technology was broken. The talk in the talkies was world-weary, heavy with cynicism. Gangster flicks like Wellman's *The Public Enemy* (1931) or Hawks' *Scarface* (1932) set the tone. The Depression was deepening. Hollywood's melancholy subtheme intensified, reaching a kind of peak in 1939 with the publication of Nathanael West's apocalyptic novel *The Day of the Locust*, the story of a depressed screenwriter which ends in a savage riot at a movie premiére.

Readers of *Brave New World* (1932) may be surprised that Huxley ever endured more than a few weeks in Hollywood, so bitter is his satire of the new film industry. Indeed, *Brave New World* reads at one level as a broad indictment of the new Californian civilization. In the future-scape of the novel, human beings are products. They no longer have parents, but are grown in the vast Hatcheries; "mother" and "father" are dirty words. Emotional bonds are subversive. Some people are bred for the elite classes, some for the middle ranks, and others as slaves. Pleasure is the glue that holds the society together. Huxley foresaw that a tyranny of pleasure would be far more durable than a tyranny of fear; it was a point that he argued with his friend George Orwell concerning *Nineteen Eighty-Four*. In a tyranny of pleasure – of carrots, not sticks – the slaves have solid reasons to remain slaves. By contrast, Orwell's characters would have solid reasons for rebellion. Suffering and the threat of suffering do not subdue people utterly and forever, as history shows. They rise up. Unlike the fearful inhabitants under the eyes of Big Brother, the denizens of

Huxley's dystopia spend all their free time engaging in mind-less entertainments ("the feelies," which add tactile sensation to the sight and sound of cinema), having recreational sex with a variety of partners (loyalty to one person is frowned on and promiscuity is a social duty), literally worshipping technology, and taking drugs (*soma*). Bodily pleasure numbs the whole world. Meanwhile, old age as we know it has been banished. The old no longer have time for reflection. "Now," we learn,

> such is progress — the old men work, the old men copulate, the old men have no time, no leisure from pleasure, not a moment to sit down and think — or if ever by some unlucky chance such a crevice of time should yawn in the solid sub-stance of their distractions, there is always *soma*, delicious *soma*, half a gramme for a half-holiday, a gramme for a week-end, two grammes for a trip to the gorgeous East, three for a dark eternity on the moon; returning whence they find them-selves on the other side of the crevice, safe on the solid ground of daily labour and distraction, scampering from feely to feely, from girl to pneumatic girl, from Electro-magnetic Golf Course to . . .

For Huxley, this hamster-wheel of pleasure was California taken to its logical conclusion. His 1925 visit seems to have helped form his view of modern entertainments as hypnotic, narcotic, onanistic. The feelies of *Brave New World* completely absorb the characters' attention. They leave no space for thought, so thoroughly do they engage the senses. "Movies," "talkies" — the feelies are just the next step, Huxley knew. The name also hints that the talkies' rendering obsolete of the deli-cate silents was just another routine cruelty of the technological

society. With its reliance on and delight in new technology, its occlusion of the past (the two are indivisible: Canadian philosopher George Grant speaks of "the oblivion of eternity which has characterized the coming to be of technology"), and its concomitant flight from aging and death in the insistence on youth, bodily pleasures, health, and longevity, California held many horrors for Aldous Huxley. None of these prevented him from returning in 1937 to work as an MGM scriptwriter and remaining to the end of his days. This choice to remain drew sharp criticism from the English intelligentsia. And so perhaps it was in part a psychological need to distinguish himself from his new surroundings that made him select Hollywood gargantua W.R. Hearst as the personification of the things he hated in California.

Huxley came to America on a lecture tour and stayed. Accompanied by his intense, Belgian, and sometime-lesbian wife, Maria, Huxley drove across the States. (Or rather Maria drove, for her husband was legally blind.) They spent a few weeks being fêted at Black Mountain College, the North Carolina arts colony. At Duke University the couple visited the lab of the celebrated parapsychologist J.B. Rhine. They spent several weeks in New Mexico at the withered commune of D.H. Lawrence's widow, Frieda. Huxley had edited Lawrence's letters, and Lawrence had urged him down a spiritual path. They then drove into California alongside Okie families from the Dustbowl. As they entered orange-grove country, their nostrils were flooded with the reek of spoiled fruit — the reek of surplus oranges intentionally left to rot. Meanwhile, the migrant workers went hungry. (Upton Sinclair describes the same miserable phenomenon in one of his EPIC pamphlets.) And as they drew

closer to the coast, lavish mansions hove into view. All in all, the gulf between wealth and poverty stretched horribly wide.

"Once in Hollywood, after crossing mountains and deserts, you must get into films, stay in films, or perish," Huxley remarked. "You are, as it were, wrecked on an island that does nothing but make films." Thus marooned, he beat back his considerable disdain for the studios and took a job writing scripts. The Huxleys stayed for a time at Alla Nazimova's old place, now transformed and renamed the Garden of Allah Hotel (F. Scott Fitzgerald was also in residence at that time). They socialized mostly with other European émigrés, many of whom, such as Bertolt Brecht and Thomas Mann, had fled the Nazi regime. Huxley was a well-known pacifist. In fact he was among the most famous members of the Peace Pledge Union, an organization which had been founded in 1934 by a prominent Anglican priest. (Citizens joined the PPU by sending in a postcard inscribed "I renounce War and will never support or sanction another.") Pacifism was a position Huxley found increasingly awkward to maintain as the refugees from Hitler poured in. Moreover, his native country was gearing up for war. He responded with a blizzard of articles denouncing militarism. Although George Orwell defended him, writing that "Anyone who wants to put peace on the map is doing useful work," many of Huxley's contemporaries back in England, finding the case for war increasingly persuasive, became angry with him. How could he preach pacifism from the safety of California? But he did. Huxley was under mounting pressure (it got much worse later, when bombs began dropping on London). It was a strain to feel the disapproval of so many of his fellows, people he respected. The poet C. Day Lewis (his grandson Daniel became

a film star) described Huxley damningly as ". . . some miserable figure, standing with face averted from the ruin and filth around him." Finally, Huxley was crestfallen to find himself on the same side as William Randolph Hearst.

Hearst argued vigorously from his many platforms that America should let the Europeans fight this one out alone. It wasn't so long since people had spoken of the 1914-1918 conflict as the War to End All Wars. Governments had vowed that war was over for good, that humanity would transform itself. Now, the Esperanto-dreams of the League of Nations forgotten, they were preparing to do it again. Hearst's pacifism was of a different stripe than Huxley's. He was an isolationist, an America First proponent, whereas Huxley was an absolute pacifist; he rejected force altogether. Still, they were both pacifists at a tricky time.

There were other connections too — Hearst had hired Huxley as a foreign correspondent some years before, and both were friendly with Anita Loos, the child-sized writer with the brunette bob who, after Griffith hired her to write scenarios in 1911, had practically laid Hollywood's foundations herself. She and Huxley got along famously. At 4'8" and 6'4" respectively, they made a good sight gag. (He said he'd like to keep her as a pet.) Loos was now living in a splendidly modernist Richard Neutra-designed house on the ocean at Santa Monica, on an expensive stretch of land known as "the Gold Coast." She got the Huxleys invited to a party at Marion Davies' palatial 110-room "beach house" nearby. White, colonial-style, and made up of five interconnected buildings, it was crammed with paintings and statuary. Hearst built it for his mistress because San Simeon was too far from Hollywood for the weekdays — 200

miles to be exact. Silent star Colleen Moore called Marion's place "the largest house on the beach − from San Diego to the Canadian border." It was the scene of one glitzy party after another.

There the Huxleys met The Chief. Maria quite liked Hearst, terming him "a nice madman." Aldous emphatically did not. Huxley hated being lumped into an antiwar club with the Man of Appetite. He could truly admire only one human type: the monk. He advocated non-attachment and saw Hearst as the antithesis of the monk, as a man ridden by furious cravings. In him the writer saw a self which, indulged in all its whims, had billowed hideously. (For his part, Hearst nursed a modest grudge against this English brainbox for once claiming that "every dog thinks its master is Napoleon. Hence the popularity of dogs.") The next novel Huxley produced, *After Many a Summer Dies the Swan*, is a rejection of Hearst and his greedy appetites, of Hollywood, of America itself. One even senses a desire to set himself apart from mankind: the book rejects virtually all human projects.

Huxley's caricature of Hearst in *After Many a Summer* is lurid. The portrait by Orson Welles in *Citizen Kane* is actually kinder, though it hurt Hearst more − perhaps because movies meant more to him than books did. The novel, which marks Huxley's turbulent passage from satirist to mystic, introduces a whole parade of unattractive characters in a bizarre setting. California is presented in terms of startling contrasts − between human figures as much as anything else. Human folly stands out all the more sharply set against the Californian backdrop of infinite potential. An exceedingly cultivated Englishman named Jeremy Pordage comes to Los Angeles to do scholarly work at a

Aldous Huxley's long form and pale visage stuck out against the California backdrop. Here is Huxley circa 1930, shortly after his arrival in Hollywood. PHOTO: GETTY IMAGES

San Simeon-like castle. He has been hired by its owner, the hair-raisingly crass old moneybags Jo Stoyte, to sort through some ancient and valuable papers. Stoyte has acquired these materials and all the opulent contents of his castle without the

faintest idea of their true import; he has only the idea of their prestige. Stoyte collects compulsively, without an iota of knowledge or appreciation. He asserts his mastery of high culture by buying it up.

The description of Pordage's arrival in Los Angeles is a black-comical retelling of the Huxleys' own arrival by car. Pordage is lucky enough to have a chauffeur, who drives him proudly past the stars' mansions. "The houses succeeded one another, like the pavilions at some endless international exhibition. Gloucestershire followed Andalusia and gave place in turn to Touraine and Oaxaca, Dusseldorf and Massachusetts. 'That's Harold Lloyd's place,' said the chauffeur ... 'And that's Charlie Chaplin's. And that's Pickfair.'" Here Huxley stresses the deracinated and fragmented quality of Los Angeles, where so much of the architecture and art is simply scavenged from more rooted traditions elsewhere. The overcultivated Pordage serves as a foil to all this vulgarity. Seeing his employer's home for the first time, he is astonished. "All at once, through a gap between two orchards, Jeremy Pordage saw a most surprising sight. About half a mile from the foot of the mountains, like an island off a cliff-bound coast, a rocky hill rose abruptly ... On the summit of the bluff and as though growing out of it in a kind of efflorescence, stood a castle. But what a castle! The donjon was like a skyscraper." Pordage dubs it "the Object." This vision is swiftly juxtaposed with an image of gaunt transients – Depression poor from Kansas. Again, the contrast between garish waste and poverty is startling.

Jo Stoyte has a special use for the destitute. He visits poor children in their orphanages and soup kitchens to bask in their youthful innocence, making himself feel younger in the

process — rather like Hearst, who surrounded himself with frolicking young people at all times. The denial of aging and death is Stoyte's major activity. Two people are indispensable to him: his nubile mistress, known as "the Baby," and his longevity specialist, Dr. Obispo. (The Baby and the devilish Dr. Obispo are having an affair behind the old man's back.) Stoyte is shackled by fear and greed. This Hearst-figure amasses everything — the objects, the Object, the babies, the Baby, the doctor and his potions — as a barricade against death. Rather like the sexed-up old men of *Brave New World*, Stoyte keeps himself busy with chicks, youth serums, and acquisitions. Like Hearst, a well-known necrophobe, Stoyte dislikes keeping company with other aging people. Pordage's is one faded and rickety body that makes him nervous. In one scene, Pordage complains of feeling sluggish. Learning his age, Stoyte is reproachful: "Only fifty-four? Ought to be full of pep at fifty-four. How's your sex-life?"

In another scene, Pordage joins Stoyte at one of the millionaire's many businesses, the Beverly Pantheon cemetery. With this passage Huxley inaugurates a tradition: English writer marvels at American funerary practices. (Evelyn Waugh's Hollywood novel, *The Loved One*, and Jessica Mitford's exposé. *The American Way of Death*, would follow.) At the Beverly Pantheon, where the locals buy their plots, death is crowded out by imagery of the vigorous body — "forever youthful, immortally athletic, indefatigably sexy." There were "statues wherever you turned your eyes. Hundreds of them, bought wholesale, one would guess ... all nudes, all female, all exuberantly nubile. 'Oh, Death,' demanded a scroll at the entrance to every gallery, 'where is thy sting?'" Here, in contrast to Saint Paul's theology,

redemption comes via the solid healthy flesh. Noting that Muslim paradise offers centuries of lovemaking, the narrator observes that "the new Christian heaven, Progress," would add golf and swimming to that. (It seems that golf was a special *bête noire* of Huxley's.)

After Many a Summer showcases a rare collection of fools, pompous asses, cynical libertines, ninnies, whores, and hedonists. Huxley approves of only one character – Propter, who lives independently in a shack and speaks of enlightenment. This character was modelled upon a friend of Huxley's, a contemplative Irishman named Gerald Heard, who had also recently moved to California and with whom he gave a series of antiwar talks. Propter has many compelling things to say, but the problem from the reader's perspective is that the character comes across as a mere mouthpiece for Huxley's opinions.

The novel says no to many things in a time when the air was thick with answers and people were choosing sides. Huxley continued to assert that nothing in the modern world could solve the riddle of man. *After Many a Summer* rejects everything except mysticism and self-sufficiency: no to business, no to every institution on Earth, no to the right wing and to the left, no to war for any reason; to aestheticism, to science as a means to anything, to progress, to romantic love – no. On the material plane, the author stressed simplicity and detachment; on the spiritual, the rolling infinite landscapes of inner space. Human beings had ventured quite far enough in the material realm, Huxley felt. Inner space, on the other hand, had scarcely been touched. The further humanity went in the name of progress, the worse things got – everything undertaken in the name of some apparent good seemed to him to crumble

horribly into dust. Every grand scheme to improve humanity's lot only worsened it; every great experiment went wrong, and every prescription had some devastating side effects. And now, a few years after the calamity of the Great War, another was in the works — for good reason, perhaps, but this did nothing to reassure Huxley. He had many misgivings about the New World. But at least it was a refuge from the Old.

~

Many of his peers in England reckoned that California had turned Aldous Huxley's celebrated brains to porridge. Meanwhile, for all his grumbling, he was leading quite a pleasant life in what he described as a "safe and still half-empty El Dorado." Rather like the early movie pioneers, he chose Southern California for the light. That reliable flood of brightness partially restored his eyesight, and he was able to get along with less than constant help from Maria. Huxley did not like to reveal how poor his eyes really were. In addition to the sun, there was the nearness of the Pacific. Huxley loved the ocean. After some time at the Garden of Allah hotel, the couple found a pretty little house in the Santa Monica Canyon, where they could also install their adolescent son, Matthew. The area reminded Maria and Aldous of Italy. They could relax in their sunny back yard and pick figs off the trees. He was writing for MGM, which was pleased to add his prestigious name to its roster. The writer Christopher Isherwood said that "the studios were terribly proud of Aldous; he thought he gave them class." As Huxley biographer David King Dunaway argues, "The name alone was impressive, indicating that Hollywood could buy anything it wanted — a human equivalent of the Spanish cloisters and the

French baronial halls which Hearst pieced together in his fantasy castle." Ironically, the man who was so critical of prestige-gathering himself became a kind of collectible. Like the penniless nobles who sold off their paintings and furniture to American collectors, Huxley needed the money.

Now, instead of working at home, Huxley had to report to the colonnaded gates of MGM with the other employees. The writers worked out of little cottages; a kind of colony emerged. Anita Loos had a cottage, as did Dorothy Parker. On their breaks the writers gathered to drink, smoke, and talk. "We were a little snooty," Loos recalled. "We weren't interested in actors ... our little group never invited any of them except Chaplin. We only wanted amusing people around with wit and intelligence." Apparently the list of such people was short. No matter — Charlie Chaplin did the work of a whole troupe of actors, telling stories and performing bits from *The Great Dictator*, his satire of Hitler, to entertain the group. Huxley and Chaplin loved one another's company. Dunaway observes that the two "met as equals in Hollywood, though in England they grew up on opposite ends." Where the writer had been born into a gilded crowd of well-born intellectuals, the actor had known real poverty in England; he had "slaved with his family in the 'public work house.'" Nowadays Chaplin, the truly universal movie star, had an entrée anywhere he pleased. (His old circus friends, meanwhile, complained that Charlie "didn't mingle with the bunch" any longer.) He grew very close with Huxley and was a frequent guest at his house. Huxley had a bit of a crush on Chaplin's wife, the actress Paulette Goddard, but then so did everyone. She was wildly attractive, with satiny white

skin, dark hair, beautiful eyes, and skimpy outfits. Paulette was reportedly the model for the sexy "Baby" character in *After Many a Summer*.

Aldous's circle of friends grew wide. Anita Loos describes a picnic which included a motley band of movie stars, intellectuals, and Indian dignitaries — notably Jiddu Krishnamurti, the man who Annie Besant had anointed as Theosophy's Chosen One. Loos later recalled "one particular outing with *dramatis personae* so fantastic they might have come out of *Alice in Wonderland*. There were several Theosophists from India, the most prominent being Krishnamurti. The Indian ladies were dressed in saris ... Aldous might have been the giant from some circus sideshow; Maria and I could have served as dwarfs ... Greta [Garbo] was disguised in a pair of men's trousers and a battered hat with a floppy brim that almost covered her face; Paulette [Goddard] wore a native Mexican outfit with colored yarn braided into her hair. Bertrand Russell, visiting Hollywood at the time, Charlie Chaplin, and Christopher Isherwood all looked like naughty pixies out on a spree."

Southern California was a place where such picnics emerged quite naturally. Aldous was happy to live in a spot which drew people like Krishnamurti, a man he felt he could truly admire. Loos calls him a Theosophist, but by this time, 1938, Krishnamurti had put the organization behind him. His story is a strange one. He had lived for years as Theosophy's designated Messiah. Two prominent Theosophists close to Annie Besant had run across the gentle and introspective boy idling with his brother on the banks of a river near the Theosophical compound in Adyar, India. The year was 1909. Inclined to believe

Jiddu Krishnamurti, Theosophy's designated messiah, renounced his role in 1929. This photo was taken circa 1910.

that the great spiritual leader of the new age would soon make himself known to them, the Theosophists had been keeping their eyes peeled. They were drawn to young Krishnamurti at once and felt that he was the figure they were seeking, the one who could effect a great synthesis of world religions. It was said

that the boy's aura was absolutely clear and radiant — as was his face, for Krishnamurti was very beautiful. He was slender and elegant, with large dark eyes and a narrow aquiline nose. He looked like an aristocrat, and he was one — a Brahmin, high-caste, though the family was quite poor. It was an irresistible combination for the Theosophists. When they learned that the boys' mother was dead, they resolved to ask the father for custody. He gave it readily enough, though he came to regret the decision. Krishnamurti was fourteen when he was officially dubbed the new "World Teacher," or Messiah.

White-haired Annie Besant, leader of the "Adyar" branch Theosophists of Krotona and later of Ojai, California, who had broken from Katherine Tingley's group at Point Loma, took this new Messiah and one of his brothers, Nitya, to England. There they received an education at the hands of tutors, emerging with elegant accents and tailored suits to boot. Krishnamurti was launched as World Teacher, leader of the Society's Order of the Star of the East (he himself was that star). Meanwhile, his father tried in vain to reclaim paternal rights. The father now saw the Theosophists as puppeteers, putting words in his son's mouth in an effort to create the image of a reincarnation of Jesus. The claim that Krishnamurti was the successor to Christ disturbed some Society members, most notably the German Theosophist leader Rudolph Steiner, for whom Christ was qualitatively different from all other men and therefore irreplaceable. Steiner rejected the whole modern World Teacher project, and he disliked what he saw as Besant's overemphasis on Eastern mystical traditions at the expense of Western ones. Besant subsequently threw him out of the Society. He then formed Anthroposophy, the doctrine which underpins his celebrated

Waldorf schools. Many other Theosophists went with him. However, the majority accepted Krishnamurti as the latest in a supposed line of World Teachers and went to sit at his feet.

He became immensely famous, getting lots of attention from the press (one journalist wrote of his "Bond Street clothes and Valentino hair-cut") and drawing huge crowds of adoring disciples wherever he went. In 1922 he arrived in California, the designated capital for the New Age. His appraisal of the place is typically Theosophical. "One can already see that a new mode of thought is coming into being ... a new race is being created," he wrote to disciples. Krishna and Nitya went to live at the Theosophical compound in the fragrant Ojai valley, near Los Angeles. Theosophy counted many adherents in the movie colony, and Krishnamurti often met with the stars — the great John Barrymore, for example. He was photographed visiting the set of Cecil B. DeMille's *The King of Kings* (1927), a life of Christ and one of the last great silent movies. There was talk of Krishnamurti getting the lead role in a biopic of the Buddha. In Hollywood, where people placed much faith in beauty, personal charisma, and good blood as well, and where they hungered for someone to bring spiritual guidance and comfort to their fragile lives, Krishnamurti was well received. All things considered, it was lucky that he was a mild-mannered man and not inclined to exploit others. The only worldly thing about "Krishanji" was his keen interest in fast and fancy cars.

In 1929 Krishnamurti was involved in a serious car accident. It seems to have changed his perspective. Shortly afterwards, he abruptly turned the Theosophical Society upside-down. Thousands of members — mostly wealthy, well-born, and creative types — had gathered for an annual meeting (the "Star

Camp") on the estate of a Dutch aristocrat. They were looking forward to hearing wise words from their adored teacher, Krishnamurti and were waiting to hear what was in store for Theosophy. The elegant Indian appeared before this huge crowd and spoke through a microphone. What he said shocked them. He announced the dissolution of the Order of the Star of the East. He did not want to be the World Teacher, he said. The new World Teacher was a silly concept anyway. "For eighteen years you have been preparing for this event, the Coming of the World Teacher," he told them. "... You are all depending for your spirituality on someone else, for your happiness on someone else, for your enlightenment on someone else." He did not want to be that someone. He did not want to be part of an organization at all. Krishnamurti's unexpected move devastated the Theosophists and embarrassed his sponsors. Annie Besant was crestfallen at the loss of her anointed one. Meanwhile, rival Theosophist Katherine Tingley lost her life in a car accident that same year, and the stock-market crash ushered in a more gloomy and austere era for people in all walks of life.

Breaking ties with Theosophy, Krishnamurti continued his speaking tours, urging pacifism and personal freedom from psychological blinders of all kinds. Many of his former disciples now shunned him, but he still drew big audiences. Sometimes he spoke from behind a screen, perhaps because he disliked the emphasis on his appearance — a theme that his admirers return to again and again. (Habitually crusty George Bernard Shaw, for example, described him as "the most beautiful human being I ever saw.") Krishnamurti did not want his appearance to stand in the way of what he was saying. His self-effacing ways impressed certain people.

Krishnamurti horrified great numbers of Theosophists when he abdicated his throne, but won the respect of Aldous Huxley and his ilk. The young Indian had put away his thousands of smitten followers, his official position, his protector Annie Besant, and even the certainty of a roof over his head when he broke up the Order of the Star of the East. The writer shared Krishnamurti's spiritual sensibility, yes, but it was that act of *renouncing* that made him so irresistible; an anti-Hearst, in fact. Krishnamurti and Huxley were almost perfectly in tune at that time. Huxley was increasingly certain that the only answer for man lay in the ancient practices of prayer, trance, and meditation. Inner vision was something of which every human being was potentially capable – and which held a special enchantment, incidentally, for a man facing physical blindness. Huxley and Krishnamurti forged a lasting friendship. They became neighbours. The two would go for long walks in the desert and stay up late at night, talking about mystical traditions shared by Christianity, Hinduism, Buddhism, and other religions – traditions which transcended divisions of all kinds. They talked of spiritual discipline and agreed that drugs were dangerous shortcuts to enlightenment, of a piece with the modern instant-gratification culture they despised. This did not prevent Huxley from later embarking on the extravagant experiments in psychedelia – LSD and mescaline as well as more obscure substances like ergine and carbogen – that would earn him a place on the collaged album cover of the Beatles' *Sergeant Pepper's Lonely Hearts Club Band*. It seems that Huxley approached many of his best-known projects with great ambivalence.

Aldous Huxley was a crucial figure for Hollywood culture and for the twentieth century. Although he never did fantastically well in scriptwriting, he did make important contributions to classic productions of *Pride and Prejudice* (1940), *Jane Eyre* (1944), and *Alice in Wonderland* (1951). (Walt Disney complained of Huxley's first version of *Alice* that he could understand only every third word.) To him, Hollywood was just an industry, a place where greed and the cold logic of technology had drowned out virtue. The industry gave him his bread-and-butter, however, and Southern California allowed him to think and to write a great many books — *The Perennial Philosophy*, *The Doors of Perception*, *Ape and Essence*, *Heaven and Hell*, and *Island* among them. Despite all his protestations to the contrary, he loved the place, so much so that he lived out the balance of his days in the Los Angeles area and died in the Hollywood Hills on November 22, 1963 — hours after John F. Kennedy was shot in Dallas.

Western civilization had unrolled itself as far as the Pacific shore. California, for all that the modern world had tainted it, still held the power to suggest. The coast itself embodies the question: now what? It makes the problem concrete. When geography runs out, when modernity's lavish promises culminate in the turning of technology to evil ends — in more and better weapons, in corpses — now what? That was the question that Huxley wanted to tackle, and California seemed always to be posing it. At the end of the West's trajectory, at the edge of the continent, literal space is replaced by figurative space; physical space gives way to the imaginary. It was true for Huxley as it has been, and continues to be, for so many others.

~

Huxley arrived too late for Hollywood Utopia. His criticisms of the place still resonate today. The movie town has been denounced time and again as — among other things — the graveyard of art and idealism. But that is too simple a description, for as we have seen, it was never *only* a commercial enterprise. The film colony also has the art and idealism of the silent era at its foundations. The great hopes for a new civilization on the Pacific, the playful and imaginative spirit of the movie pioneers, the sweet dream of a Universal Language to unite humanity, the bohemian colonies within the movie colony, the rich and strange vision of old gods sprung to new life, the fairy kingdoms for California, and more — all of these inform Hollywood still. Hollywood has replaced the frontier as our imaginary realm *par excellence*. The wide-open spaces of the frontier were reborn into cinema's worlds upon worlds. And while movieland has produced much that is ugly and uninspired, it also has been a source of the extraordinary. Hollywood has many hidden facets, some of them utopian in nature. We never know when these will catch the light.

Acknowledgments and Bibliography

This book grew out of a fascination with the West Coast's utopian dimension in general. I had help and encouragement from many people. Special thanks to my editor and friend, Rolf Maurer, for seeing this project through; to Audrey McClellan for all her work on the manuscript; and to Don Stewart at MacLeod's Books in Vancouver for putting me on to the Eisenstein story and providing sources. Thanks to Noah Seaman for his aid and insights, and to Phil Smith for his suggestions. Michael Patrick Hearn made some Oz material available to me. Will Thackara of the Theosophical University Press was very helpful and informative on the subject of Point Loma. My mother, Joan Haggerty, always gives me writerly encouragement. My brother, Zachary Brown, helped me find photos, as did Igor Maric.

I looked at material in the New York Public Library; the Ronald Grant collection in London, England; the London Library; and Special Collections at the University of British Columbia. The Point Loma archive is now held at the Theosophical University in Pasadena, California. The following is an annotated chapter-by-chapter list of print material that I consulted to understand how the film colony conceived of itself: what the animating ideas were, and what life was like. See the index for the movies.

ONE *Emerald Cities*

Baum, L. Frank. *The Wonderful Wizard of Oz*. Michael Patrick Hearn, ed.
New York: Schocken Critical Heritage Series, 1983 [1900]. This edition
features the original W.W. Denslow illustrations and many key critical
essays, including some early commentary on the Oz phenomenon.
Edited by America's foremost Baum expert.

——. *The Emerald City of Oz*. Chicago: Reilly & Britton, 1910.

Davis, Mike. *City of Quartz: Excavating the Future in Los Angeles*. Lon-
don: Verso, 1990. A riveting study of Los Angeles, with special emphasis
on the city's apocalyptic dimension.

Doyle, Robert A., ed. *Utopian Visions*. Time-Life Books, 1990. This book
offers an introductory tour of utopian thinkers, artists, and colonies. A
great place to start, with many colour photographs.

Hine, Robert. *California's Utopian Colonies*. San Marino, CA: Huntingdon
Library, 1953. An indispensable account of the subject, this book is
standard in the field. Hollywood appears only in one footnote, however.

Gardner, Martin and Russel B. Nye. *The Wizard of Oz and Who He Was*.
East Lansing: Michigan State University Press, 1957. A useful biography,
written at a time when Baum was beginning to receive serious consider-
ation as an artist.

McKenna, Terence. *The Archaic Revival*. New York: Harper Collins, 1991.
This is a collection of interviews and short pieces showcasing the Timo-
thy Leary of our day. Contains various exotic arguments for the use of
psychedelic drugs.

Moore, Raylyn. *Wonderful Wizard, Marvelous Land*. Bowling Green, OH:
Bowling Green University Popular Press, 1974. Moore gives an inspired
account of Baum's imaginative life, especially relative to magical and
speculative geography. Includes an introduction by Ray Bradbury.

More, Sir Thomas. *Utopia*. New York: Knopf, 1992 [1516]. Should we take
More's fictional island commonwealth as a serious model for the ideal
society? Scholars argue, but the title, punning on the Greek for
"nowhere," suggests a joke.

Tingley, Katherine. *Theosophy: the Way of the Mystic*. Pasadena: Theo-
sophical University Press, 1977 [1922]. This short selection of Tingley's
writings gives the reader an idea of the tenor of her thought – rather
airy and abstract for the most part.

Veysey, Laurence. *The Communal Experience: Anarchist and Mystical*

Countercultures in America. New York: Harper & Row, 1973. A thorough, detailed, and useful overview of an immense subject.

Wagenknecht, Edward. *Utopia Americana.* Seattle: University of Washington Bookstore, 1929. Wagenknecht should be required reading for any student of American popular culture. He was among the first to write reflectively about movies and about Oz, and his work is animated by real love.

Washington, Peter. *Madame Blavatsky's Baboon: Theosophy and the Emergence of the Western Guru.* London: Secker & Warburg, 1993. A skeptical account of the ideas which interest so many elite Westerners. Will help readers understand to what degree the New Age originates with Theosophy.

TWO *White Magic*

Baum, Frank Joslyn. "The Oz Film Company," *Films in Review,* vol. VII (1956), 329-33. This is an account of the Baum family's Hollywood years by the writer's son. Gives us the distinct flavour of the film colony prior to 1920.

Boller, Paul F. Jr. and Ronald L. Davis. *Hollywood Anecdotes.* New York: Morrow, 1987. A patchwork of colourful memories from many of the major players. Covers the early and mid periods.

Brownlow, Kevin. *The Parade's Gone By.* New York: Knopf, 1968. Brownlow, the most important historian of silent film, collected these oral accounts from the original players, directors, technicians, etc., at a time when many of them were dying. The fact that there was a certain urgency to the project makes it doubly poignant — stories of a lost world by a fading generation.

Brownlow, Kevin and John Kobal. *Hollywood: the Pioneers.* New York: Knopf, 1979. Essential reading for any student of the silent film era. The book accompanies a series of documentary videos by the same name and is based on interviews with the early inhabitants. Gives an account of the early settlement as well as the emergence of key movie genres.

Eyman, Scott. *Mary Pickford: America's Sweetheart.* New York: D.I. Pine, 1990. A slightly uneven but useful account of Pickford's life and career.

Gish, Lillian. "In Behalf of Silent Film" in Oliver Saylor, ed., *Revolt in the Arts.* New York: Bretano's, 1930. One of several highly articulate arguments for the intrinsic value of the silents.

——. *The Movies, Mr. Griffith, & Me.* Englewood Cliffs, NJ: Prentice-

Hall, 1969 [1932]. Gish's autobiography makes us understand why she was so inspired by D.W. Griffith and gives the intriguing story of a pioneering actress.

McCarthy, Mary Eunice. *Hands of Hollywood*. San Francisco: Dolores Press, 1929. This odd little book is a piece of Hollywood boosterism which, because it was written in the 1920s, gives us a feel for the way people thought of the place.

Pickford, Mary. *Sunshine and Shadow*. Garden City, NJ: Doubleday, 1955. Pickford's autobiography gives us a picture of her professional life in the theatre and in the movies as they began to emerge from the nickelodeons.

Seldes, Gilbert. *Movies for the Millions: an Account of Motion Pictures, Principally in America*. London: B.T. Batsford, 1937. An intriguing overview of cinema as an art form, written a few years after the talkies took hold. Useful for understanding the contemporary view of Hollywood. Seldes is credited with being the first intellectual to write appreciatively of Chaplin's art.

Sklar, Robert. *Movie-Made America: a Cultural History of American Movies*. London: Chappell & Co., 1975. An early postmodern account of the industry which has done so much to form America's sense of itself. Definitely worth reading.

Quarrington, Paul. *Civilization and Its Part in my Downfall*. Toronto: Vintage, 1995. This novel, which features a Griffith-esque overweening director, succeeds in recreating the circuslike atmosphere of very early Hollywood. Recommended.

Wagenknecht, Edward. *The Movies in the Age of Innocence*. Norman, OK: Oklahoma University Press, 1962. Mature work by the great historian of popular culture – an account of the silent film era and its impact on audiences.

Whitfield, Eileen. *Pickford: the Woman Who Made Hollywood*. Toronto: Macfarlane, Walter and Ross, 1997. This account stresses Pickford's business acumen in founding United Artists and argues that her Little Girl persona was one of feistiness and endurance. Whitfield strives to restore Pickford's stature in a world that remembers only Chaplin.

THREE *A Glistering God*

Anger, Kenneth. *Hollywood Babylon*. San Francisco: Straight Arrow, 1975. This cult classic provides a tour of the most scandalous tales of the silent

era, the stuff that brought Will Hays to Hollywood. Anger, a child actor and underground filmmaker, recounts horrifying gossip with glee.

Eksteins, Modris. *Rites of Spring: the Great War and the Birth of the Modern Age.* New York: Anchor, Doubleday, 1990. Eksteins' account of modernism and the Great War tells us much about the cultural backdrop of the times. Fascinating analysis of modernist ballet, which directly influenced many key Hollywood figures.

Everson, William K. *American Silent Film.* New York: Oxford University Press, 1978. One of the most solid overviews of the subject. Everson is particularly strong on the ideas that drove early filmmakers.

Lambert, Gavin. *Nazimova: a Biography.* New York: Knopf, 1997. Definitive biography of a Russian actress who made a big impression on Hollywood in her day.

Morris, Michael. *Madame Valentino: the Many Lives of Natacha Rambova.* New York: Abbeville Press, 1991. Morris has made a valuable contribution to Hollywood history with this book about the self-fashioned designer, the woman who brought Art Deco to the movie town and arguably was responsible for creating Rudolph Valentino. Beautiful illustrations and photographs.

Paglia, Camille. *Sexual Personae: Art and Decadence from Nefertiti to Emily Dickinson.* New York: Vintage Books, 1991. Paglia applies the Nietzschean categories of Apollonian and Dionysian to culture at large. Her argument lends itself to an interpretation of Hollywood as a resurgence of pagan gods. An exhilarating read.

Paris, Barry. *Louise Brooks.* New York: Knopf, 1989. A satisfying biography of this fascinating figure. Paris covers Brooks' dancing years, her movie acting, and her passage to film critic.

FOUR *Beyond Babel*

Bergan, Ronald. *Sergei Eisenstein: A Life in Conflict.* New York: Overlook Press, 1999 [1997]. An excellent and balanced overview of the great filmmaker's life and work.

Eisenstein, Sergei. *Immoral Memories.* Herbert Marshall, trans. Boston: Houghton Mifflin, 1983. Eisenstein's autobiographical sketches are too impressionistic to be fully satisfying, but it gives the reader a sense of his inner life.

Geguld, Harry M. and Ronald Gottesman, eds. *Sergei Eisenstein and Upton Sinclair: the Making and Unmaking of "Que Viva Mexico".* Lon-

don: Thames & Hudson, 1970. This book is an epic account of a specific episode. The reader can learn much about how group artistic projects can spin out of control — and a great deal about Eisenstein and Sinclair both.

Geguld, Harry M., ed. *Focus on D.W. Griffith.* Englewood Cliffs, NJ: Prentice-Hall, 1971. A collection of essays, including some from contemporary commentators (e.g., Lillian Gish), together with some excerpts from interviews with the pioneering director.

Gish, Lillian. "A Universal Language." *Encyclopedia Britannica.* 14th ed., 1932, s.v. "motion pictures." This essay arguing the merits of silent film appears in a larger section on motion pictures. Written in the midst of the argument over the talkies, it gives readers a sense of what was felt to be at stake.

Henderson, Robert M. *D.W. Griffith: His Life and Work.* New York: Oxford University Press, 1972. A major biography, lavishly illustrated. Henderson's book reveals the new respect accorded to silent film in the 1960s.

MacGowan, Kenneth. *Behind the Screen: the History and Techniques of the Motion Picture.* New York: Dell, 1965. A very useful history of the development of the art and the industry of American cinema, with emphasis on the practical and business aspects. Illustrated with posters, financial documents, and technical images as well as movie stills.

Montagu, Ivor. *With Eisenstein in Hollywood.* New York: International Publishers, 1967. Montagu was a cultivated English Communist who kept company with Eisenstein and tried to see that he made a film in Hollywood circa 1930. No film was made, but the story of the Russians' time there is worth reading. Charlie Chaplin appears often.

Porter, Katherine Ann. *Hacienda: A Story of Mexico.* Camden, NJ: Harrison of Paris, 1934. Porter visited the Eisenstein team on location in Mexico, and this story is based on her experiences.

Schikel, Richard. *David Wark Griffith: An American Life.* New York: Simon & Schuster, 1984. This biography does justice to the epic sweep of Griffith's career, emphasizing the archetypally American elements: Griffith worked his way up from nothing and was both a romantic and a realist in outlook.

Seton, Marie. *Sergei M. Eisenstein: A Biography.* rev. ed. London: D. Dobson, 1978. Seton gives a clear idea of Eisenstein's intellectual development and unique work habits.

Sinclair, Upton. *The Autobiography of Upton Sinclair.* New York: Har-

court Brace, 1962. Sinclair gives an account of his many projects, artistic and political. We learn about his New Jersey utopian colony, various political campaigns, and of course the ill-starred partnership with Eisenstein.

FIVE *The King of California*

Brooks, Louise. "Marion Davies' Niece" in *Lulu in Hollywood*. New York: Knopf, 1983. Brooks' account of time spent at San Simeon gives us an idea of what went on behind Hearst's back.

Loos, Anita. *Gentlemen Prefer Blondes* and *But Gentlemen Marry Brunettes*. New York: Penguin, 1998 [1925, 1927]. Loos' satirical novellas are excellent background reading, for Loos was a Hollywood pioneer and also a close friend of Hearst and Marion Davies. These books give us a sense of the era and a knowing perspective on the relations of blondes and their millionaires.

Murray, Ken. *The Golden Days of San Simeon*. New York: Doubleday, 1971. Tales of the movie stars who visited Hearst's palace and the parties they had there.

Nasaw, David. *The Chief: the Life of William Randolph Hearst*. Boston, New York: Houghton Mifflin, 2000. The last word in Hearst studies. This is a massive and well-researched biography.

——. "Earthly Delights," *New Yorker*, March 23, 1998, 66 ff. Nasaw styles San Simeon as a kind of utopian community and presents Hearst's love affair with Marion Davies in a freshly sympathetic light.

Sinclair, Upton. "I, Governor of California, and How I Ended Poverty: a True Story of the Future." Los Angeles: End Poverty League, 1934. During Sinclair's ill-fated bid for governor he produced a number of campaign pamphlets. This one is written in mock-novella style and describes a California thriving after Sinclair's socialist plan is put into effect.

Swanberg, W.A. *Citizen Hearst*. New York: Scribner's, 1961. Swanberg's biography is a classic in the field. Emphasizes the epic sweep of Hearst's influence in America.

Winslow, Carelton M. Jr. and Nicola L. Frye. *The Enchanted Hill: the Story of Hearst Castle at San Simeon*. Los Angeles: Rosebud Books, 1980. As the title suggests, this book tells the story of an estate — but what an estate. Many colour photographs.

SIX *On Prospero's Isle*

Blau, Evelyne. *Krishnamurti: 100 Years*. New York: Stewart, Tabori & Chang, 1995. This is a collection of interviews, reminiscences, and reprints intended to mark the guru's centenary. It was put together by adherents and is edited a little unprofessionally, but contains much valuable material. Lots of black-and-white photographs.

Dunaway, David King. *Aldous Huxley Recollected*. New York: Carroll & Graf, 1995. Huxley's biographer has assembled this collection of anecdotes and provided commentary. Huxley always kept interesting company, and they had much to say. Creates a cumulative portrait.

——. *Huxley in Hollywood*. New York: Harper & Row, 1989. Dunaway focuses on the second half of Huxley's life and seems interested in the degree to which the writer anticipated 1960s counterculture. Well-researched and detailed.

Field, Sidney. *Krishnamurti: the Reluctant Messiah*. New York: Paragon House, 1989. A brief memoir by a man who knew Krishnamurti when the two were California adolescents. Shows how Krishnamurti's role as spiritual leader meant that he could not indulge his interest in girls. Krishnamurti emerges as someone who, while aware of worldly pleasures, is not going to be led by them. The book describes the life of Theosophical families in Hollywood.

Grant, George. "Justice and the Right to Life" in *The George Grant Reader*. Toronto: University of Toronto Press, 1998. Grant's critique of life in a technological age makes an excellent companion-piece to *Brave New World*. Highly recommended.

Huxley, Aldous. *After Many a Summer Dies the Swan*. Harmondsworth, Middlesex, England: Penguin, 1955 [1939]. This novel, satirizing Southern California, is set at a San Simeon-like castle. Huxley at his most misanthropic.

——. *Brave New World*. New York: Harper & Row, 1946 [1932]. Huxley's dystopia, featuring cloning and a genetically stratified, instant-gratification society, may ultimately prove more prophetic than Orwell's *Nineteen Eighty-Four*.

Vernon, Roland. *Star in the East: Krishnamurti: The Invention of a Messiah*. New York: Palgrave Press, 2000. Vernon's biography is objective – skeptical, yet generally sympathetic to Krishnamurti – and includes a telling analysis of Theosophy's millenial expectations.

Index